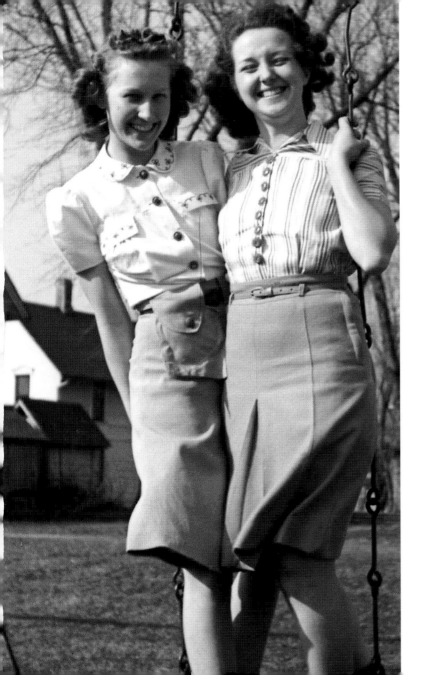

SUNDAY AFTERNOON ON THE PORCH

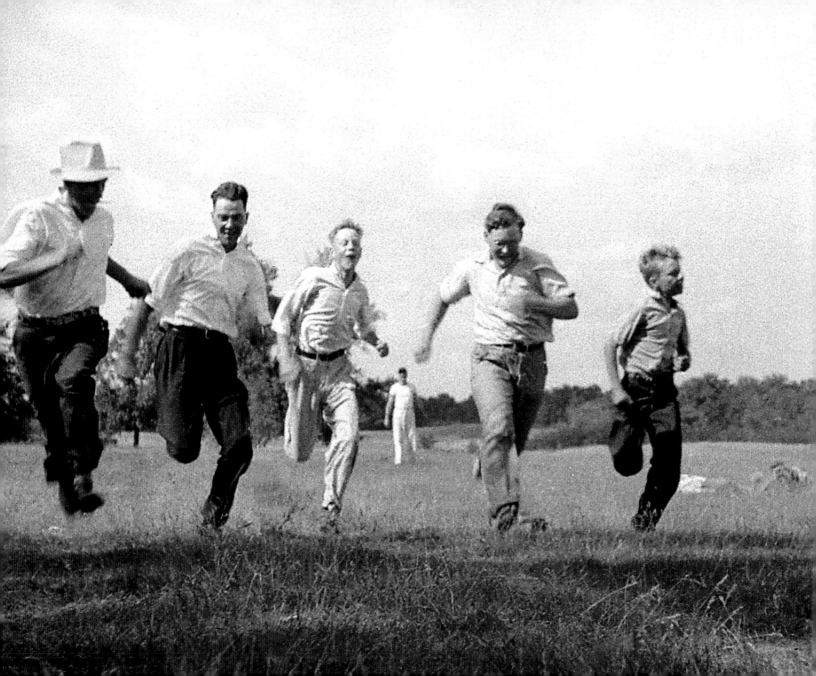

Sunday Afternoon on the Porch

REFLECTIONS OF A SMALL TOWN IN IOWA, 1939–1942

Photographs by EVERETT W. KUNTZ ✳ *Text by* JIM HEYNEN

UNIVERSITY OF IOWA PRESS, IOWA CITY

A Bur Oak Book

University of Iowa Press, Iowa City 52242
Copyright © 2008 by the University of Iowa Press
www.uiowapress.org
Printed in China

Design by Kristina Kachele Design, llc

The University of Iowa Press is a member of Green Press Initiative and is
committed to preserving natural resources.

Printed on acid-free paper

Library of Congress Cataloging-in-Publication Data
Kuntz, Everett W., d. 2003.
Sunday afternoon on the porch: reflections of a small town in Iowa, 1939–1942 /
photographs by Everett W. Kuntz; text by Jim Heynen.
p. cm.—(A Bur oak book)
ISBN-13: 978-1-58729-653-6 (cloth)
ISBN-10: 1-58729-653-5 (cloth)
1. Ridgeway (Iowa)—Social life and customs—20th Century—Pictorial
works. 2. City and town life—Iowa—Ridgeway—History—20th century—
Pictorial works. 3. Ridgeway (Iowa)—Biography—Pictorial works. 4. Ridgeway
(Iowa)—History—20th century—Pictorial works. 5. Kuntz, Everett W.,
d. 2003. 6. Photographers—Iowa—Ridgeway—Biography. I. Heynen, Jim,
1940- . II. Title.
F629.R49K86 2008 2007039378
977.7'32—dc22

08 09 10 11 12 C 5 4 3 2

Contents

Preface

THE STORY OF EVERETT KUNTZ and his photographs began when, in his senior year of high school in 1939, he left his hometown of Ridgeway, Iowa, to visit Iowa City and inquire about getting a scholarship to the university. He walked into Henry Louis's drugstore and bought a 35mm Argus AF camera for $12.50. An uncle's worn-out boot, scraps of a tin can, and a clasp from his mother's purse gave him the makings of a camera case. For the next four years, especially during the summers when he was home from college, the shutter of his trusty Argus clicked steadily around Ridgeway, population 350. Everett soon became known as the kid with the camera, and the townspeople dubbed him Scoop.

Since his pockets weren't bulging with cash, Everett had trouble making them bulge with film. He discovered a mail-order house where he could purchase discount movie reel film in bulk to use for still photographs. While other boys his age were rolling their own

cigarettes, he was rolling his own film and developing hundreds of negatives in a closet at home. His mother cooperated by stuffing a blanket under the door to seal off the light. For four years he processed negatives—more than two thousand in all—but he never had the money to print them. That final step would have to wait over sixty more years, during which he married, raised a family, and put his degree in electrical engineering to good use.

In 2002, Everett's prostate cancer metastasized, he realized he was running out of time, and he returned to his unprinted negatives. With the aid of twenty-first-century digital technology, he scanned his negatives and used Adobe Photoshop to give us the pictures we have today. A treasure trove, a time capsule of his young life in small-town Iowa, was waiting to be revealed.

Everett Kuntz died April 30, 2003, at his home in Mounds View, Minnesota.

Ridgeway, Iowa, Then and Now

THE SMALL TOWN OF RIDGEWAY, in Winneshiek County, has a total land area of 1.1 square miles and is located just off Highway 9, about ten miles from the college town of Decorah in northeast Iowa.

Ridgeway did not officially become a town until 1867, when the railway reached it. By the time Everett Kuntz started photographing the community in 1939, its population had risen to about 350. By 2000 the population was down to 293. The residents of Ridgeway were and probably still are largely of Norwegian and German descent but, according to available data, no one living there in 2000 was foreign-born.

The entire rural county of Winneshiek, where Everett Kuntz took most of these pictures, grew by only 463 between 1940 and 2000—a mere 2.2 percent—while the U.S. population as a whole grew by about 120 percent. When I visited the town for the first time in June

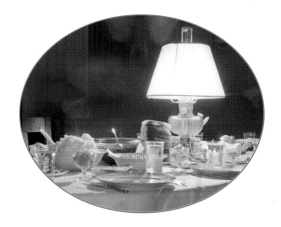

2006, in preparation for writing this book, I found it to be not only a peaceful place but a totally unthreatened place. When I knocked at the door of some of the old-timers' homes, I heard "Come in!" before I even identified myself. And I am happy to say that when I visited the Chatter-Box Cafe, I did not hear one cell phone ring while older men played cards quietly around a large round table and younger people chatted amiably at the bar. Since dial telephones did not reach Ridgeway until 1967, perhaps cell phones will kindly keep their distance for a few more decades too.

 I'd like to think that the town has not changed all that much since the days when Everett was roaming around taking pictures. I had the feeling that if I had been carrying a camera, I would have disturbed no one.

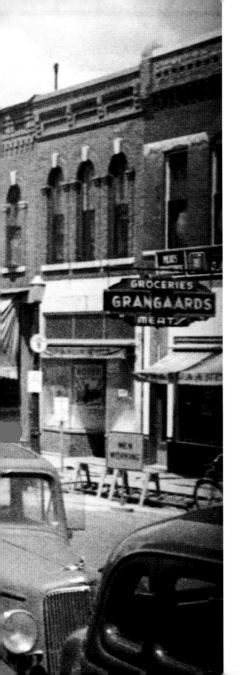

THE PHOTOGRAPHS

KEROSENE LAMP

The soft yellow light from the kerosene lamp is light cushioned for thinking.
It slows the world down and does not blaze the mind into distraction.
This is the light that knows no urgency.
See him now in the unworried kerosene light,
the way it nourishes his long, steady thoughts.

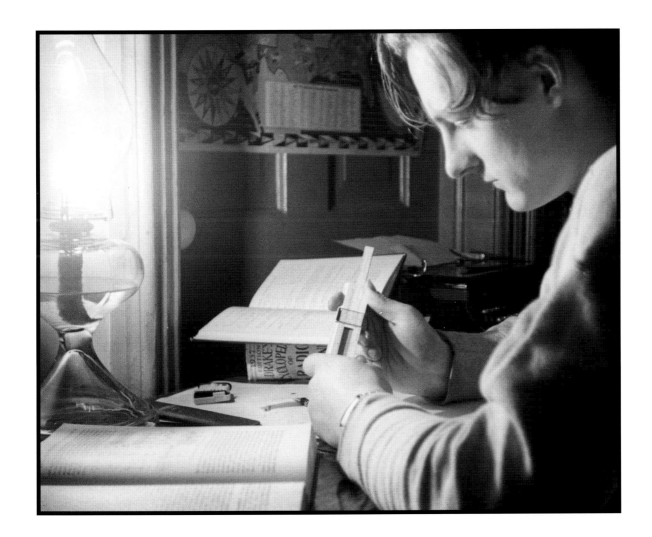

Self-portrait

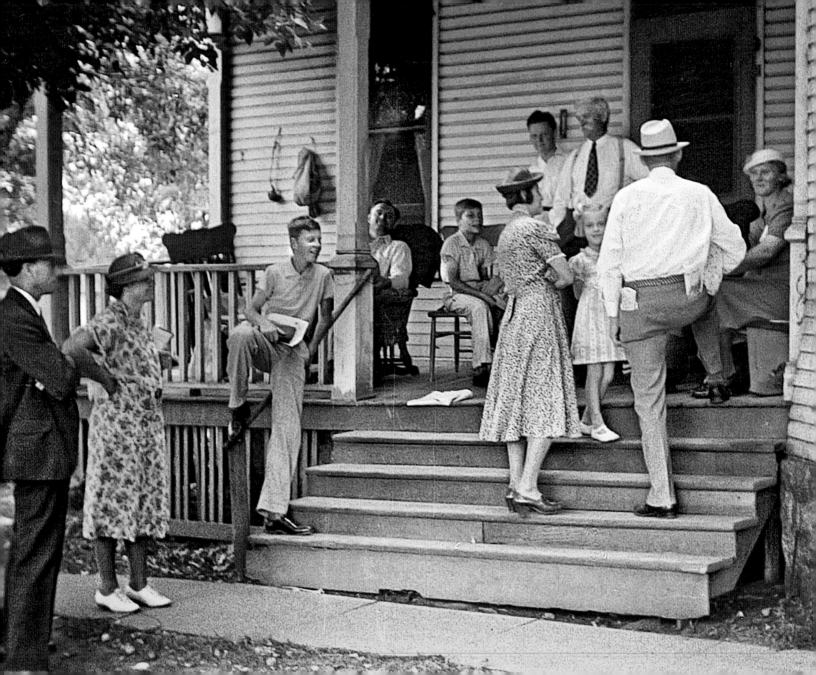

They've all just been to church and now continue their day of rest by gathering as a family in their Sunday best for this front-steps photo.

Have we dropped in on a scene from a movie set? That raised-knee stance of two of the males—isn't that from one of the great 1939 or 1940 movies? Maybe *Gunga Din? Mr. Smith Goes to Washington? The Roaring Twenties? Stagecoach? Wuthering Heights? Young Mr. Lincoln? Broadway Melody?* Whose pose have they learned—Cary Grant's? James Stewart's? Clark Gable's? Humphrey Bogart's? The young John Wayne's? Or—lest we forget—Fred Astaire's?

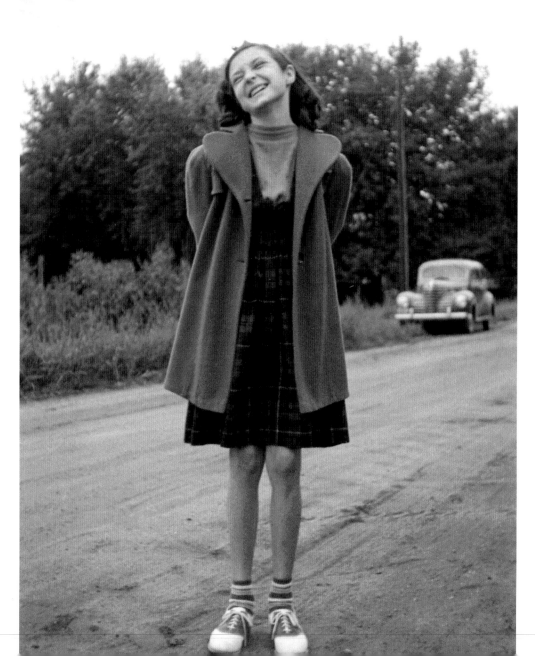

Dorcas

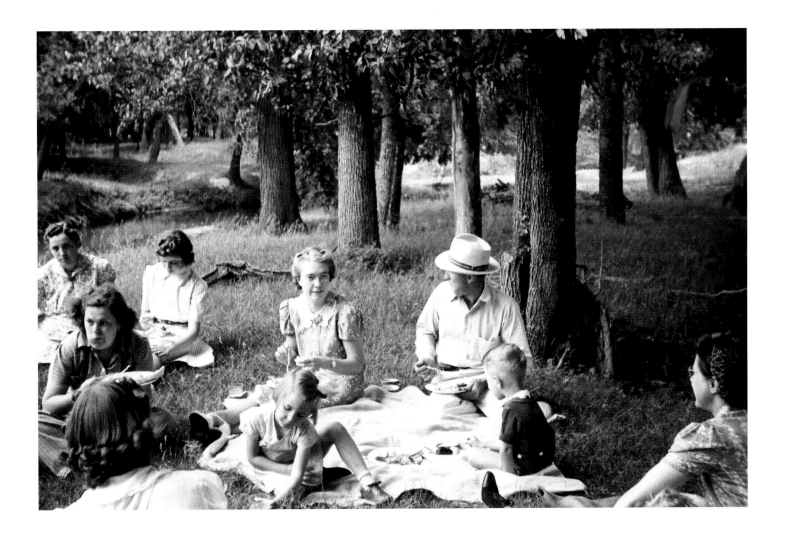

Family Picnic

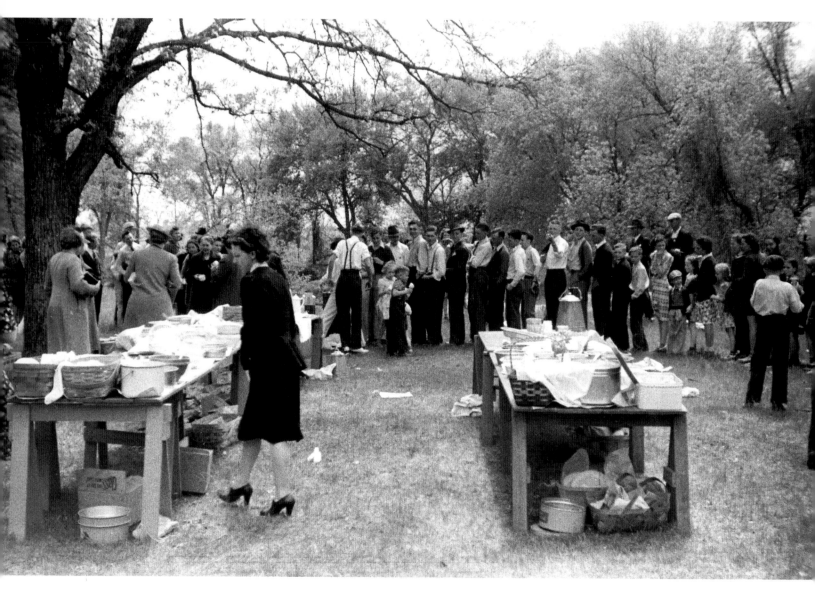

Picnic at the Turkey River

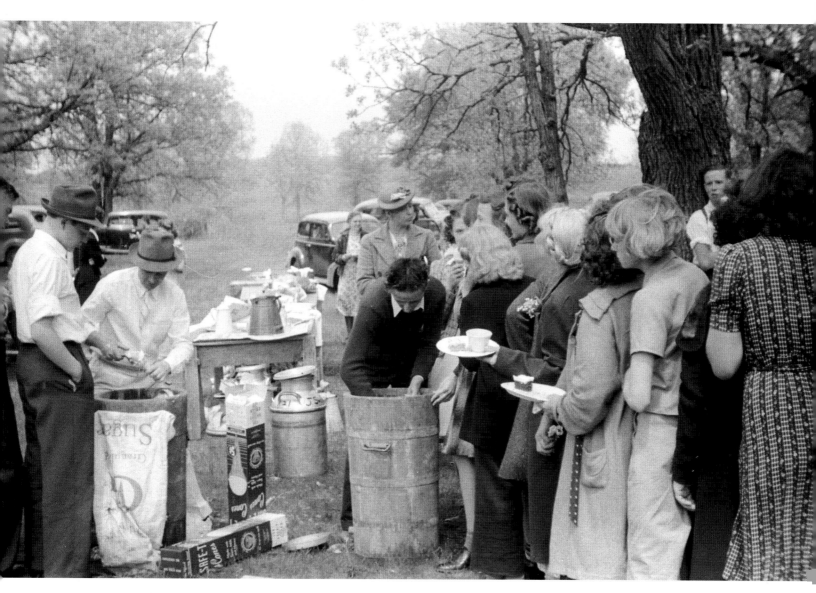

Ice Cream Social, Turkey River

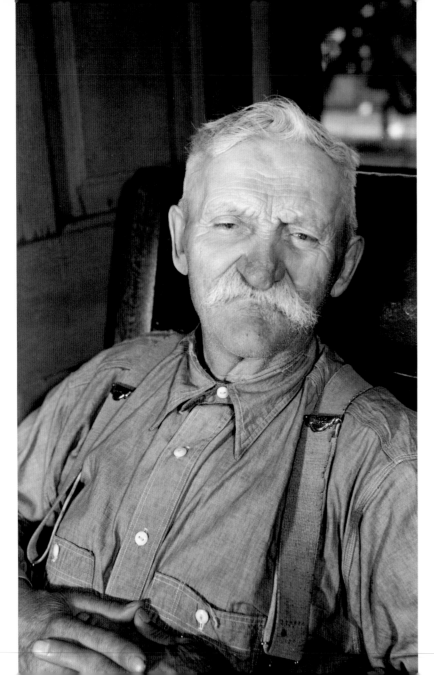

Grandpa

Several big movies come out, including *Gone with the Wind* and *The Wizard of Oz*; John Steinbeck's *Grapes of Wrath* and Robert Frost's *Collected Poems* are published; Hitler's armies advance into Czechoslovakia and Poland; the New York Yankees win the World Series; President Franklin Delano Roosevelt signs the Social Security Amendment; the Pan American Airways *Dixie Clipper* makes the first Transatlantic flight from Long Island to Lisbon, Portugal, with twenty-two passengers; Irving Berlin writes "God Bless America"; and in the small rural village of Ridgeway, Iowa, seventeen-year-old Everett Kuntz takes his $12.50 camera and starts photographing the ordinary people and events of his hometown.

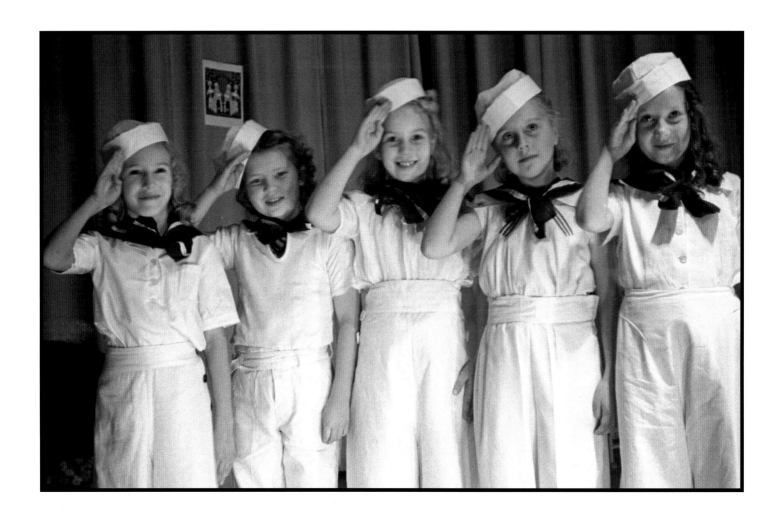

Sailor Girls

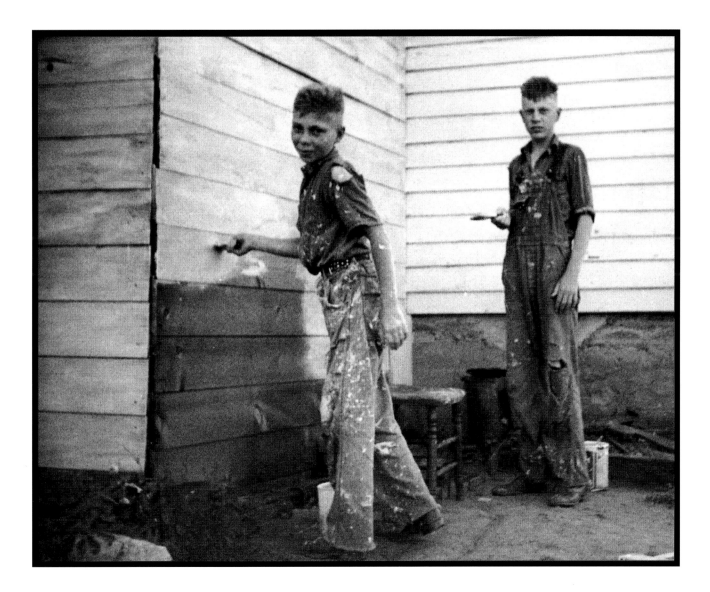

Where Is Tom?

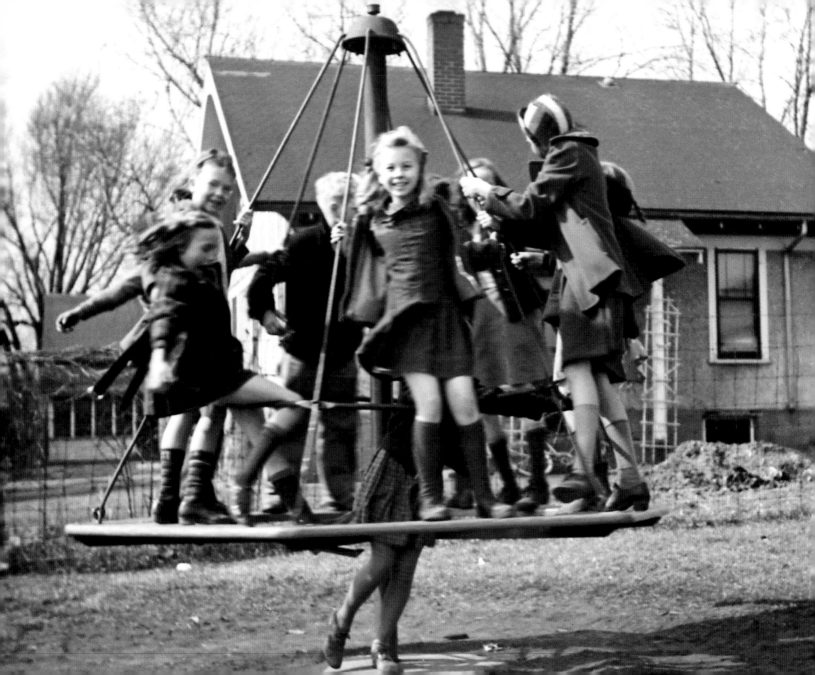

The one on the ground knows she can fling the others into space if she wants to.

They all know this is not about hanging on, it's about getting deliciously dizzy.

To fall off would not mean losing, it would mean getting the chance to push.

To hold on with one hand and scream will get somebody's attention.

To face out smiling is a personal declaration of independence.

Years later, do they realize

that being on the ground pushing prepared them for parenthood?

That leaning safely forward prepared them to balance their checkbooks?

That facing out at the spinning world prepared them for politics?

That hanging on with only one hand prepared them for a rocky marriage?

That screaming while twirling prepared them to host many dinner parties?

And learning to endure dizziness prepared them for the workplace?

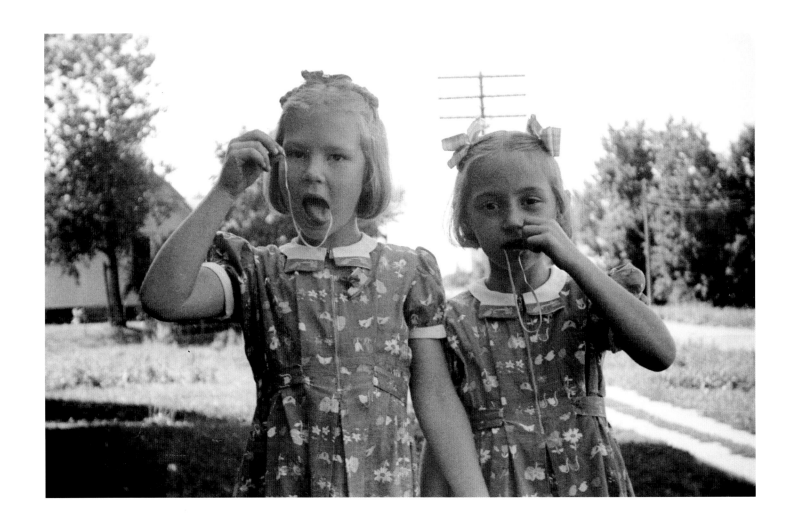

Gum Girls

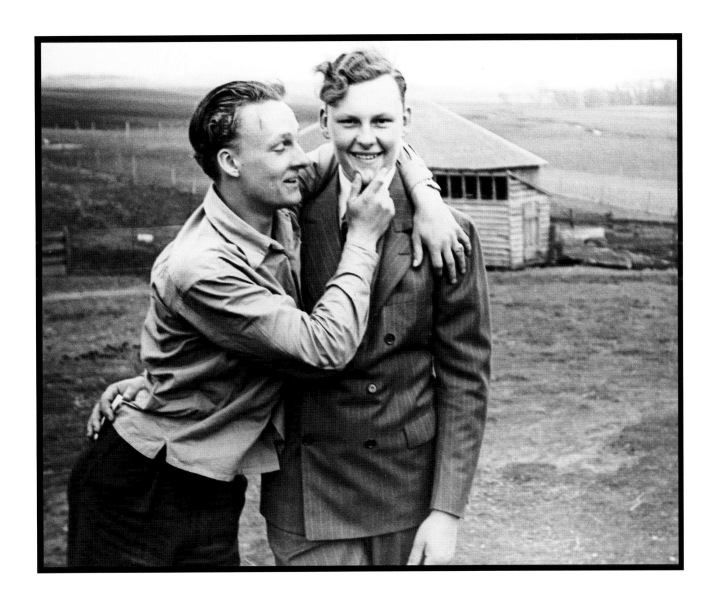

My Brother. Harold Kuntz is on the right.

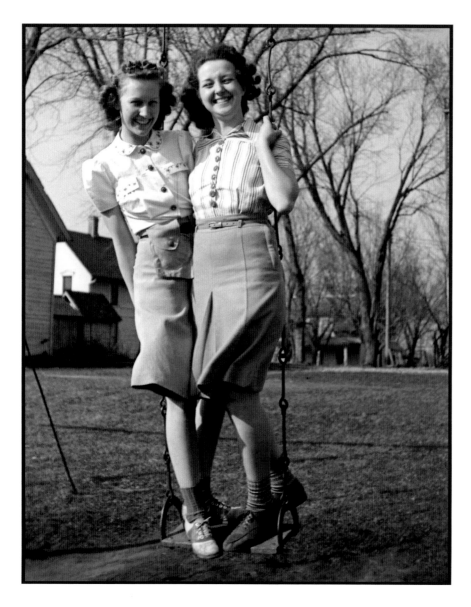

Norma and Alice

Let's not forget the women who were in the movies at the time: Bette Davis, Olivia de Havilland, Greta Garbo, Judy Garland, and Joan Crawford, to name a few. Notice the obvious care that both girls and women put into their hair, especially for pageboy styles. The camera didn't catch anyone in curlers, but you know something happened behind the scenes to make those pipe curls and pin curls. You may spot a few dressy up-dos with hair pulled up on top of the head and held in place with lots of bobby pins. Bobby pins, bobby pins: there are hundreds of bobby pins hiding in these photos. And snoods—those mesh nets that held long hair rolled under, usually matching the woman's hair color and therefore invisible. And the Veronica Lake look with its glamorous curls? Oh yes, there was hairspray at the base of the curl to hold it in, but curling irons didn't have temperature controls and were more likely to frizz hair than control it. Those hats? Are they a sign of class, or do they indicate those who did not have time to fix their hair?

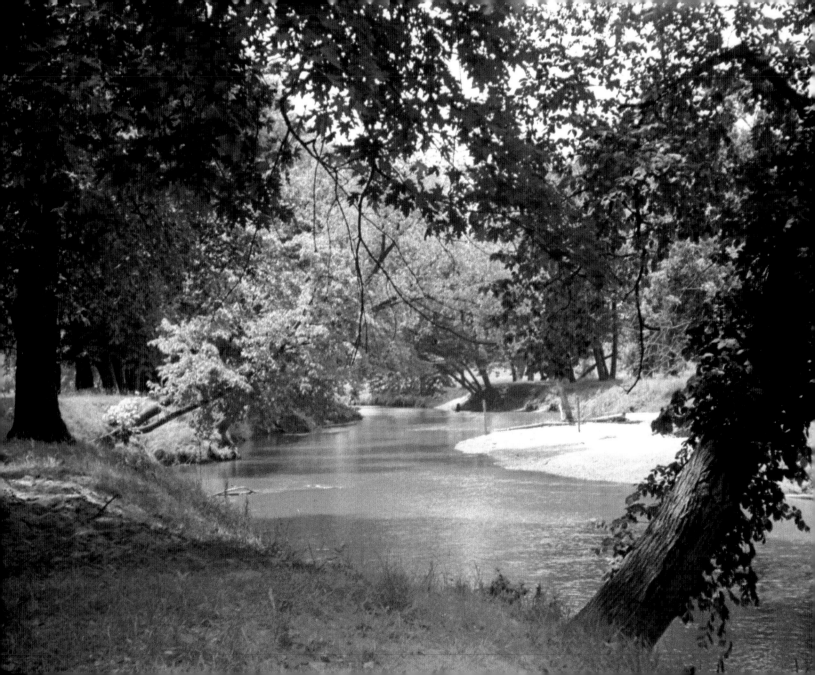

The Turkey River was like an outdoor lounge that rippled all the cares and worries of the day away. And it was free, free, free!

Everett: *That was really a pretty place down there. Especially in the springtime, the bottomland along there was totally covered with bluebells, which I haven't seen for many years anyplace. They really grew profusely there, so when you looked out that's all you'd see.*

This was the community gathering place, the place to picnic, to hold Fourth of July celebrations, to eat homemade ice cream, to skinny-dip, or simply to sit in the grass with shoes placed on the riverbank. Don't be misled by the fallen trees. The Turkey River was spring-fed and probably cleaner than some drinking water today. No wonder it drew the townspeople, young and old, again and again as it meandered along the edge of Ridgeway on its way to the Mississippi. No wonder it drew our young cameraman and his Argus AF.

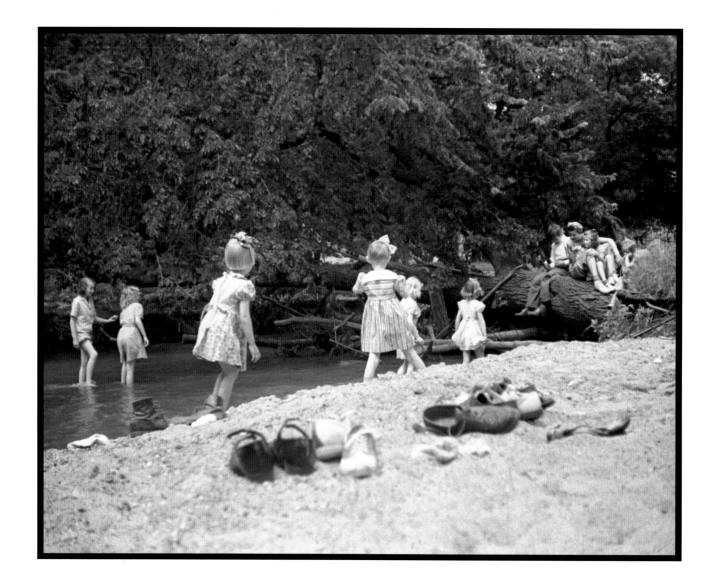

Sand and Shoes

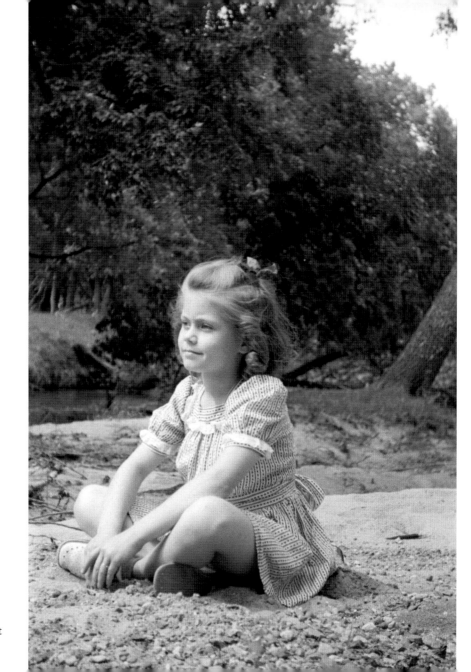

Child Portrait

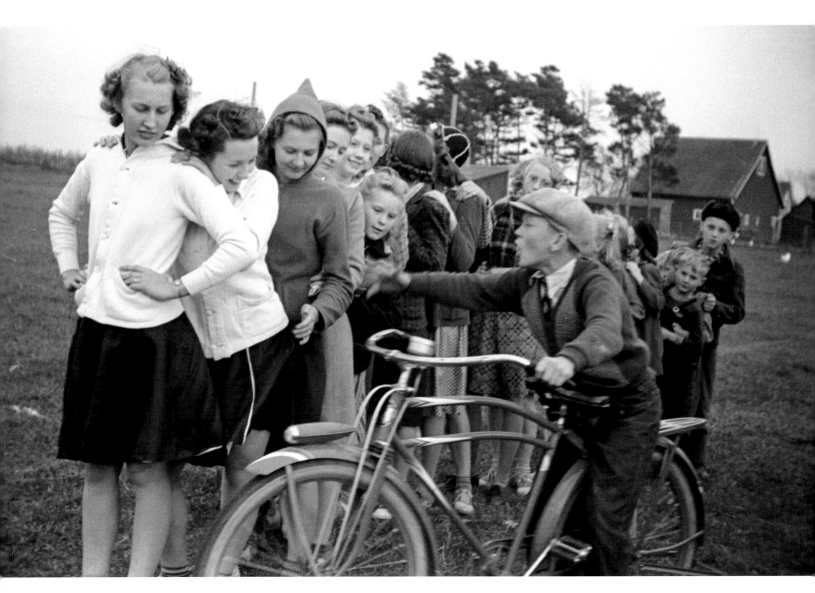

Roy's Rebuke

Little brotherly love does not pollute an older sister with praise.
It does not support an older sister's foolish hope for dignity.
Little brotherly love does not allow false security among friends,
nor does it allow a budding woman to assume she's an adult.
Little brotherly love does not honor an older sister's new hair-do,
does not honor her new dress—not her socks, not her shoes,
not her lipstick, not even her wristwatch.
Little brotherly love simply does not honor!

Little brotherly love offers the gift of ridicule.
It guards the older sister from the pitfall of pride,
from the silly comfort of age, and from the mirage of dignity itself.
Little brotherly love teaches self-composure.
It teaches the older sister to rein in anger and disgust.
Little brotherly love nourishes an older sister's humility.
It helps build her reservoir of patience
and helps perfect the art of tongue-biting under duress.
It is the one guaranteed virtue builder before womanhood.

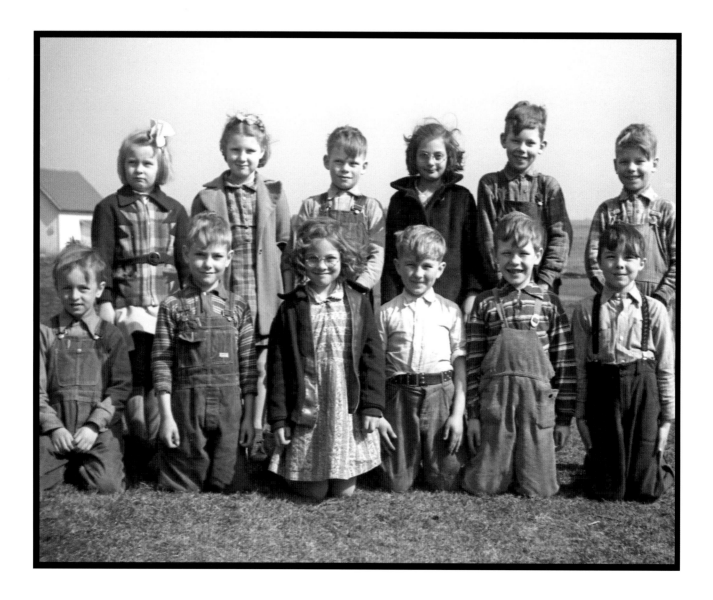

Kids in a Row

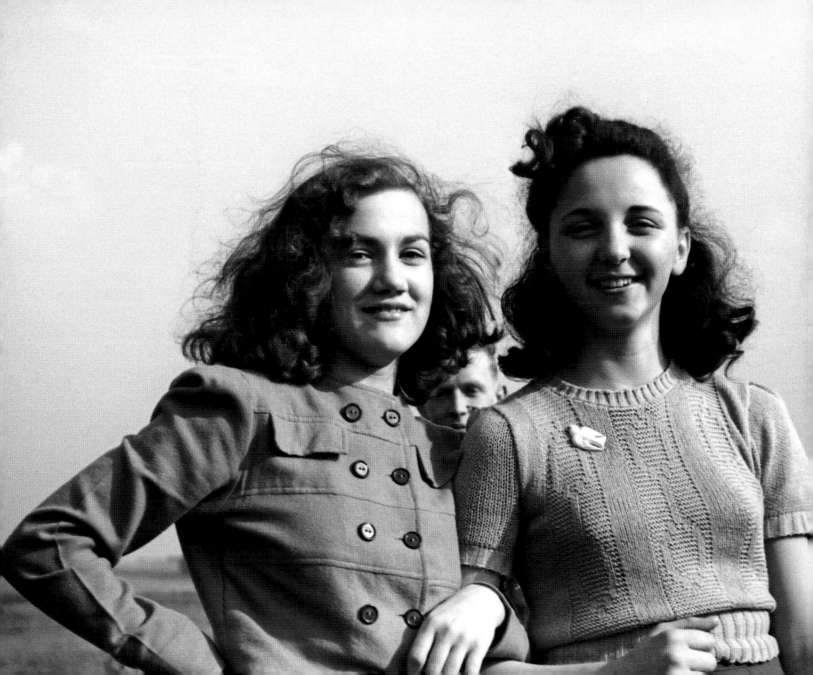

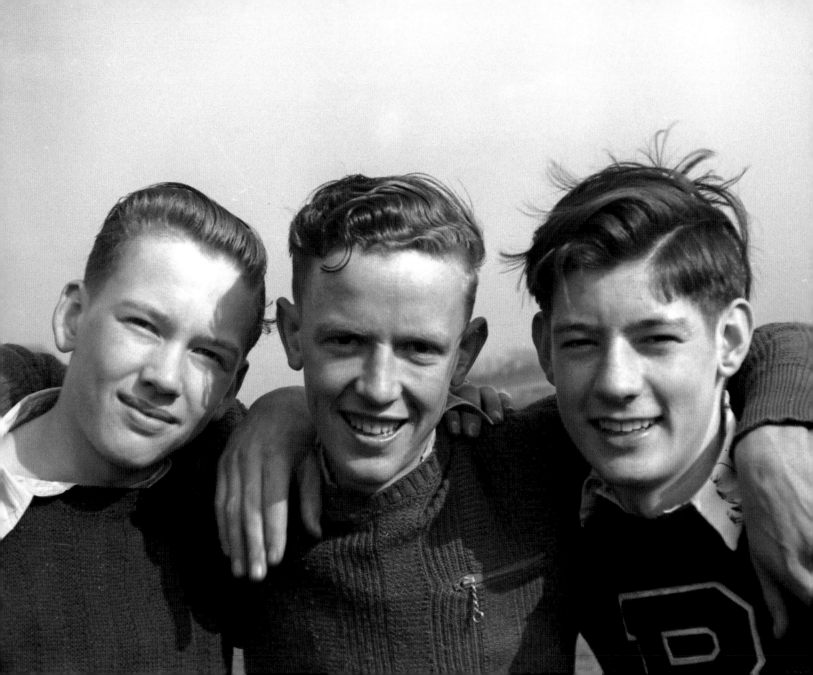

Maybe this is what they were thinking:

 You there in the twenty-first century: Do you think you do a better job with your hair than we do? Do you think you show more individuality in how you comb it? Do you think you keep your hair in place better than we do with our Wildroot Hair Cream? Do you think you're more comfortable putting your arm around your buddies, or are you afraid that others will talk about you if you seem too friendly? Are you afraid of friendship or of yourself? Can you see that we are afraid of neither? Do you think our parents spent five thousand dollars on an orthodontist to get our teeth to look this good? Do you suppose our good teeth have something to do with what we've been eating since we were babies? And what we have been drinking? And what we have not been eating and drinking? Do you like our sweaters? We know where ours were made. Do you know where yours were made?

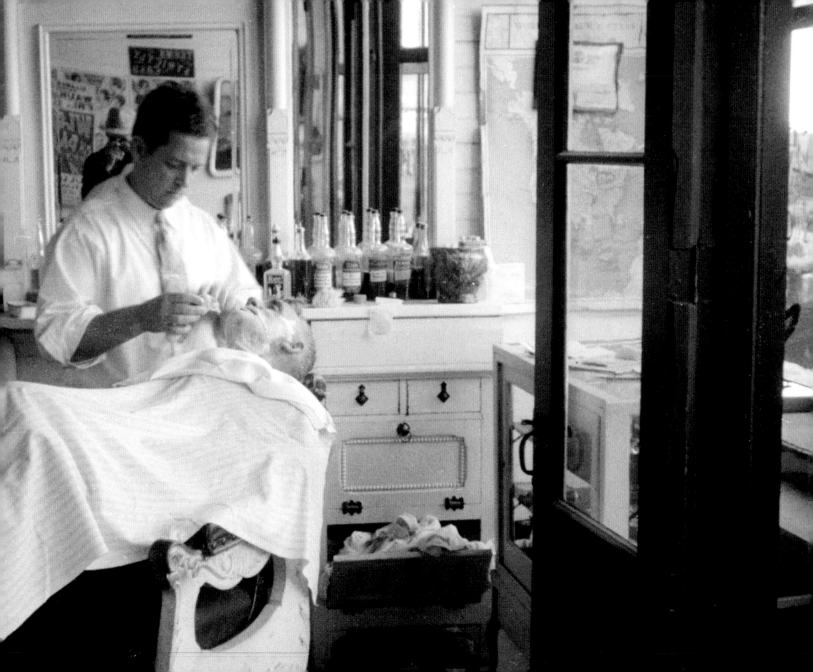

This could be seen as a sunset photograph because the drawer full of used towels tells us the day is almost over. This could be seen as a history photograph because of the map on the wall. But it's also a self-portrait. Someone once said that every good photograph is in some way a portrait of oneself.

Everett: *Now, this is the barbershop, operated by Orin Hove. Besides operating the barbershop, the room to the left of this one (there are several rooms back there) contains what was called the central office, which is telephone central for that region. I think the lines all terminated there at his central office, which was a manual switch central with the patch cords you plug in. Of course, he needed to have an attendant there so somebody slept there overnight to answer the phone in case anybody needed to make a phone call out of Ridgeway.*
Q: *The barbershop, huh?*
Everett: *Yep, it had been that way since as long as I can remember.*

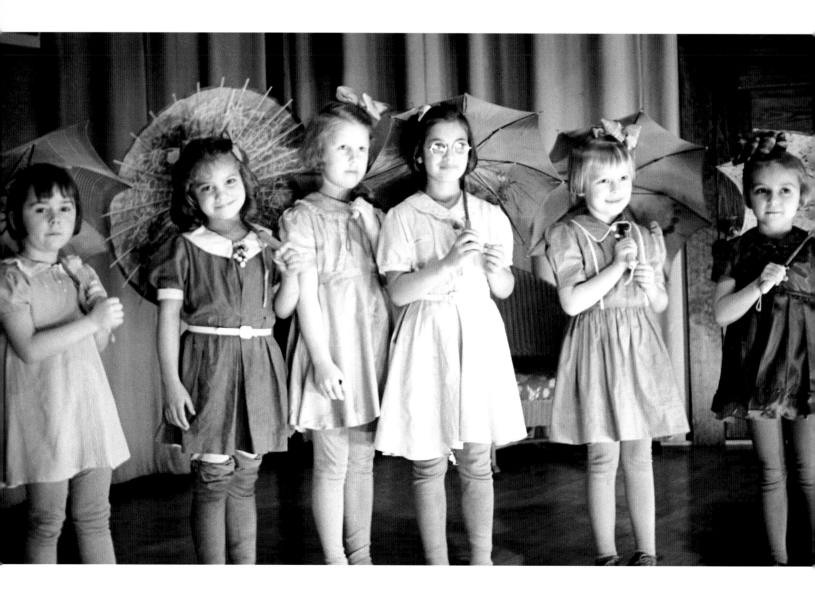

Umbrella Girls

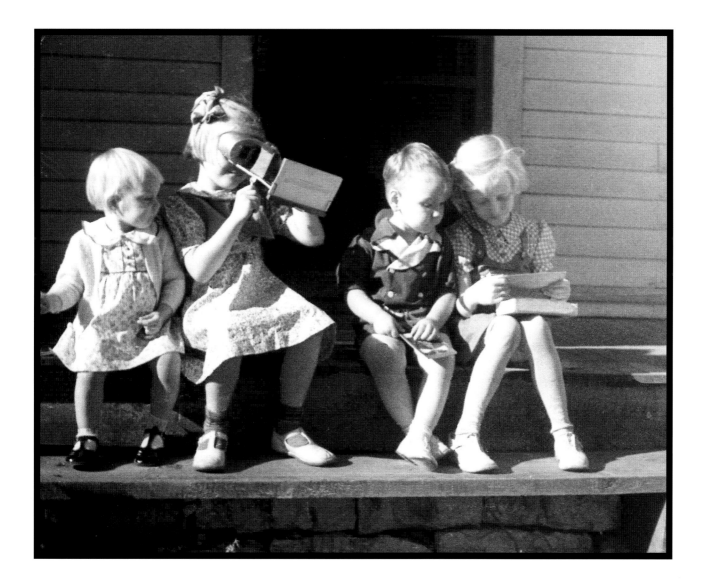

Stereopticon

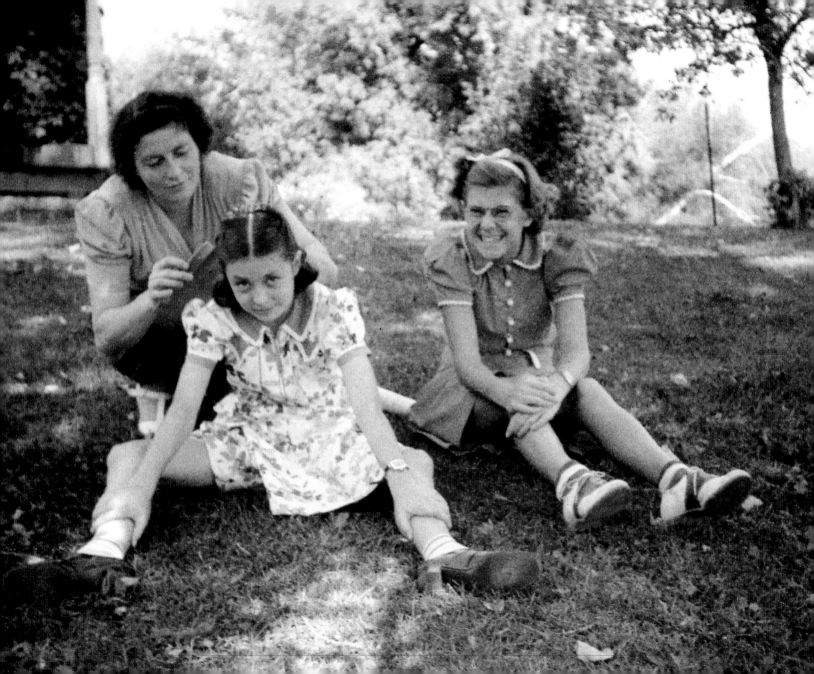

The 1940 census gives the population of the United States as 131,669,275. In the spring, the New York World's Fair begins, but across the Atlantic, before the end of July, Germany invades Norway, Denmark, Luxembourg, the Netherlands, Belgium, and France and begins air attacks against Britain.

In May, the first helicopter makes a successful flight in the U.S.

Although the Olympic games are canceled because of the war, Joe Louis defends his heavyweight championship title.

In June, the Alien Registration Act requires the registration and fingerprinting of approximately 5 million aliens living in the U.S.

Women have begun to enter the workplace. Within the next three years, the number of women working outside the home will increase by 56 percent.

In September, the Selective Training and Service Act is passed by Congress; it calls for all American men between the ages of twenty and twenty-six to register, with active duty to be one year.

In October, the forty-hour work week goes into effect.

The Cincinnati Reds win the World Series.

Ernest Hemingway's *For Whom the Bell Tolls* is published.

In July, when Roosevelt is nominated for an unprecedented third term, he chooses his agriculture secretary, an Iowan named Henry Wallace, to be his running mate. In November, Wallace is elected with Roosevelt.

In the spring of 1940, Everett Kuntz returns to Ridgeway after his freshman year at the State University of Iowa in Iowa City. By this time, in the fields that he photographs during his summer vacation, half the corn is picked mechanically.

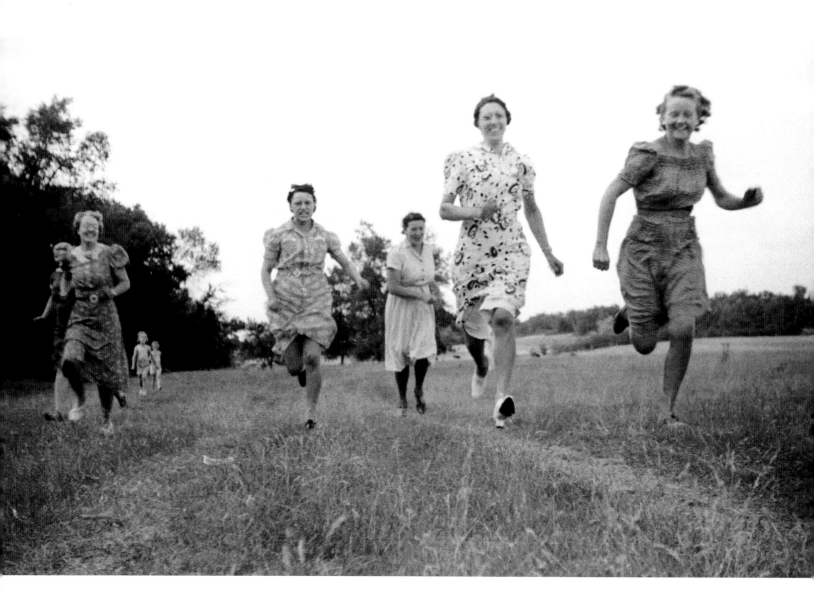

Ladies' Race

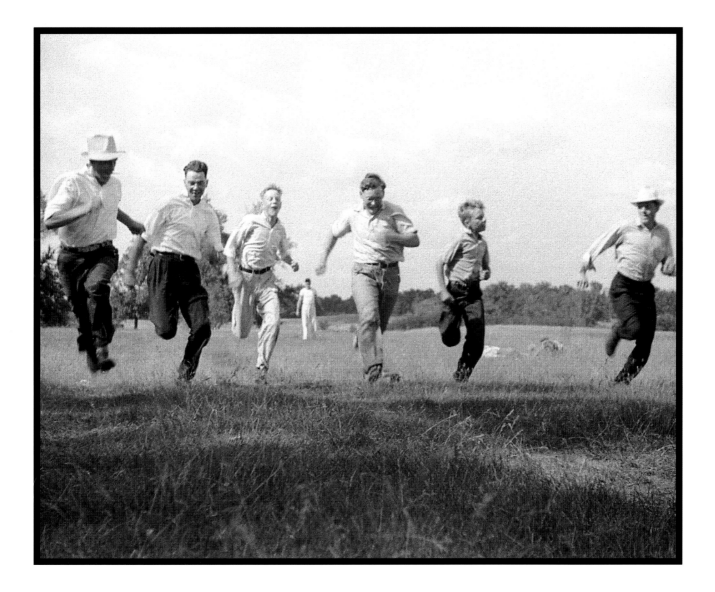

Men's Race

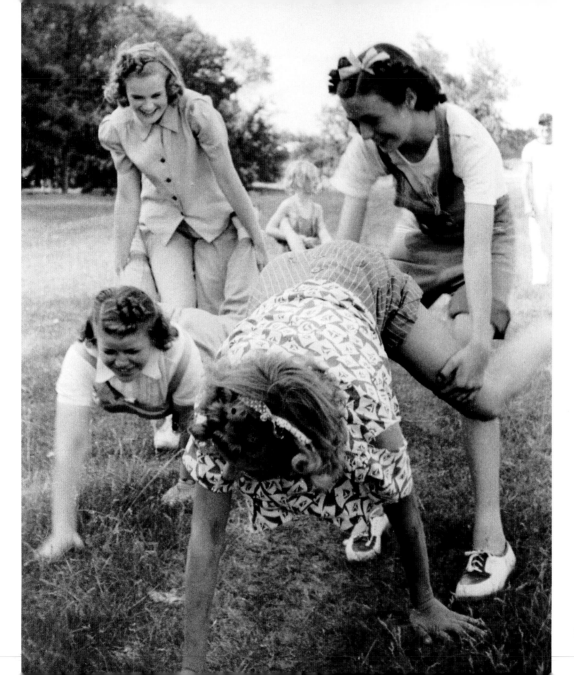

Wheelbarrow Race

Were things different then?

Was there innocence in silly positions, someone's hands on their ankles, their butts up, their noses to the ground?

Is the grinning boy in the background thinking different thoughts than a boy would be thinking today if he saw a girl his age holding the backside of another girl his age into the air as she clumsily tried to make her way toward the finish line?

Is the laughter at this scene a happier laughter than the laughter at an all-night kegger?

Did they know how to stage intentional embarrassment so they wouldn't have to worry about accidental embarrassment?

Was humiliating each other their way of reminding each other that they were all in this big human carnival together?

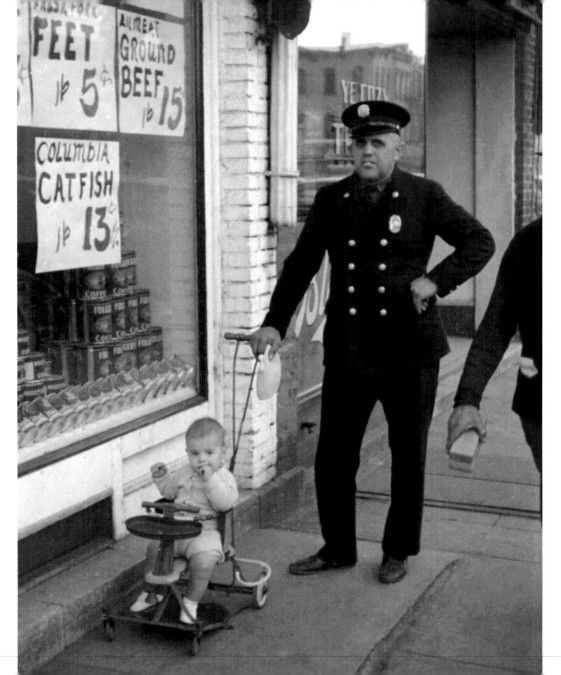

On Duty

Happy faces cannot hide the Great Depression's shadow: sidewalks settling away from store fronts, fences sagging in disrepair, rubble scattered around the street, paint spattered against brick buildings, the drugstore soda bar left unwiped, a creek half-filled with broken branches, an unmended rip in a trouser pocket, a mound of straw left unstacked. See people rising from the hungry years and moving toward the years of war. No wonder the pleasure with each other looks so real: they know it is the surest security they have.

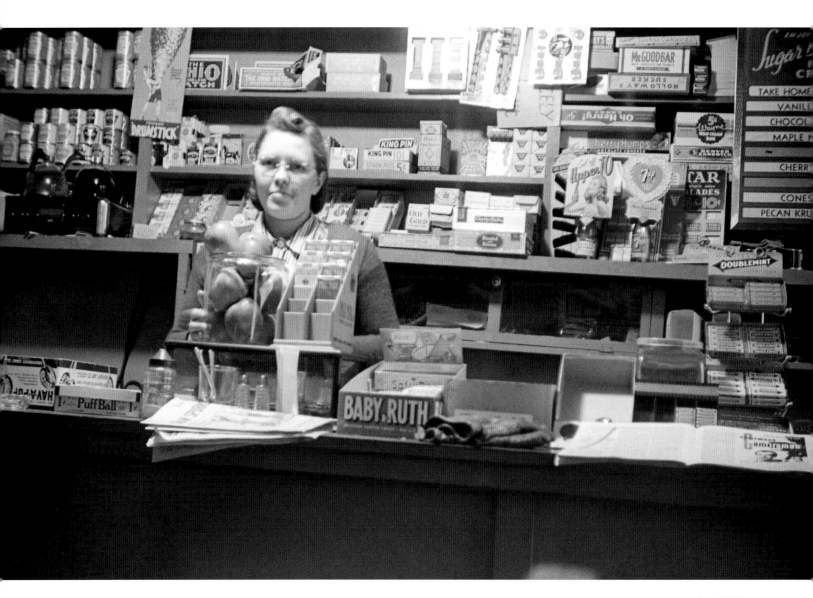

Soda Grill

Cherry Humps, Have-a-pop
Puff Balls and Pall Mall
King Pin Upper Ten
Lucky Strike and Old Gold
Philgas and Pep
Doublemint Drumstick
Prince Albert in a can
Half and Half Baby Ruth
Velvet Mr. Goodbar
Oh Henry Royal Crown
Holloway's Sucker
Heinz and Mandalay
with Lipton close behind.
Ohio Matches, anyone?

BRAND NAMES THE CAMERA SAW

43

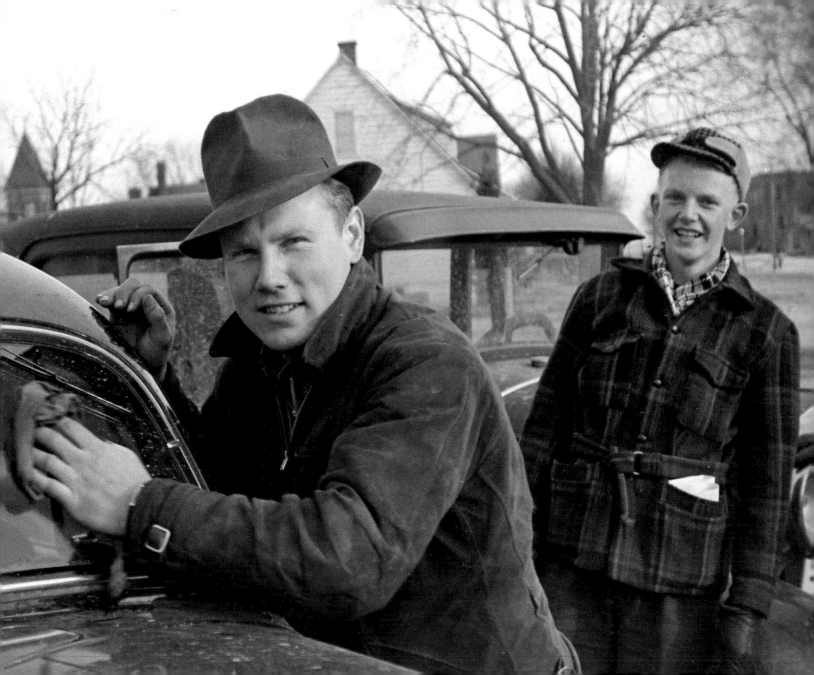

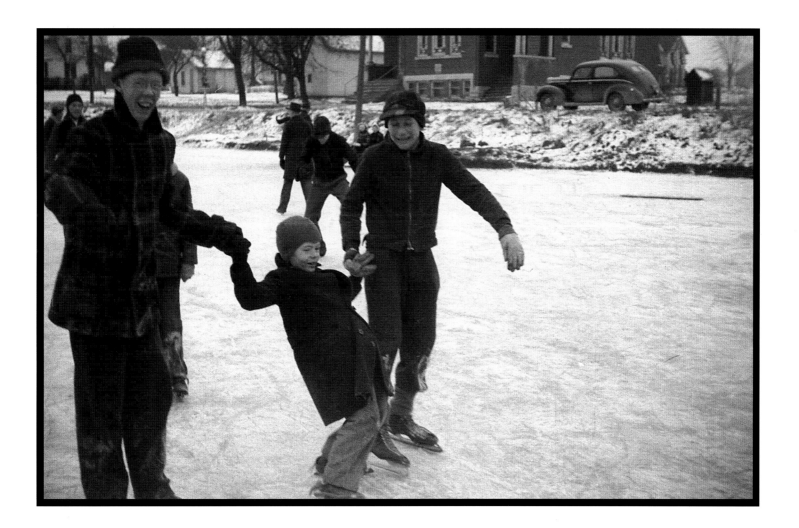

Anderson's Car Wash

Skating Rink, Methodist Church

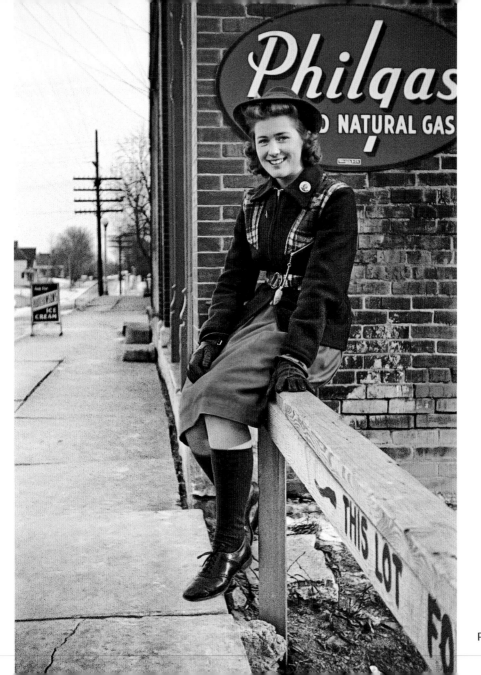

Philgas

Q: *This pretty girl standing by the Philgas?*

Everett: *Oh, that's another picture of Clara.*

Q: *What's her last name?*

Everett: *Gilbertson. She's still alive and lives in Bloomington.*

Q: *Has she seen this?*

Everett: *Yes, I sent her some prints.*

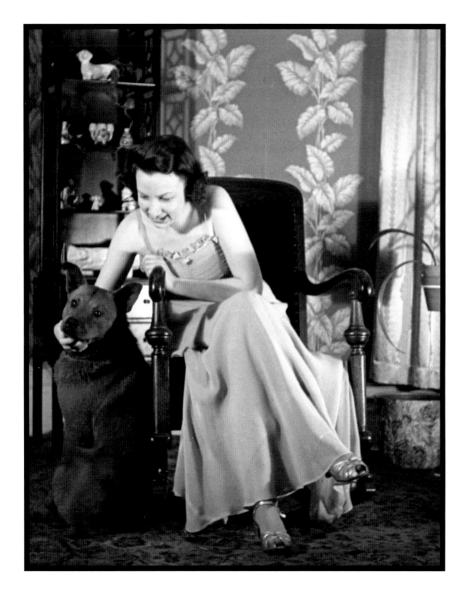

Beauty and the Beast

Q: *Who's that pretty woman?*

Everett: *Strangely enough, I don't remember. Anyway, that girl has a nice dog there and I think the background—well, the whole thing kind of illustrates the way things looked at the time.*

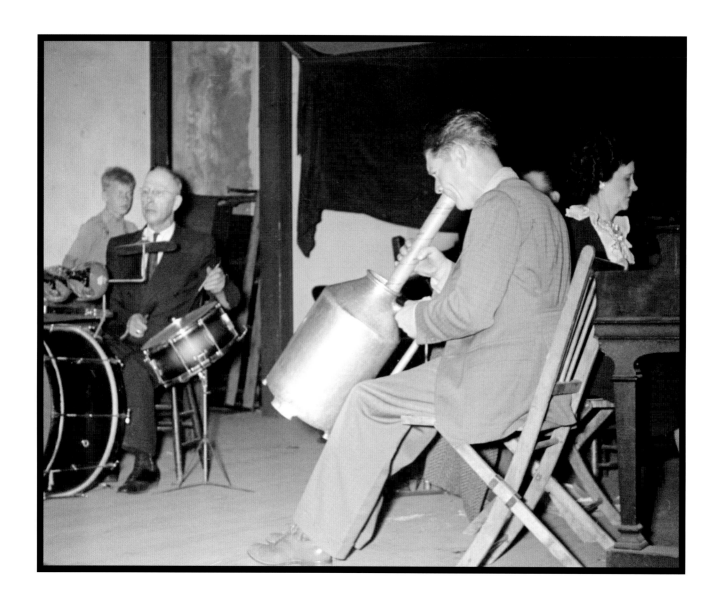

Clifford's Bazooka

"Pop five cents, popcorn five cents, movie ten cents: you could go out and have a good time for a quarter."—Eighty-eight-year-old Ridgeway resident Morris Bergan, remembering the years 1939 to 1942

But what lines would they remember after seeing their ten-cent movie?

"Toto, I've a feeling we're not in Kansas anymore."—Judy Garland as Dorothy Gale, *The Wizard of Oz*, 1939

"Frankly, my dear, I don't give a damn."—Clark Gable as Rhett Butler, *Gone with the Wind*, 1939

"Look up! Look up! The clouds are lifting."—Charlie Chaplin as Adenoid Hynkel/A Jewish Barber, *The Great Dictator*, 1940

"Rosebud!"—Orson Welles as Charles Foster Kane, *Citizen Kane*, 1941

"Here's looking at you, kid."—Humphrey Bogart as Rick Blaine, *Casablanca*, 1942

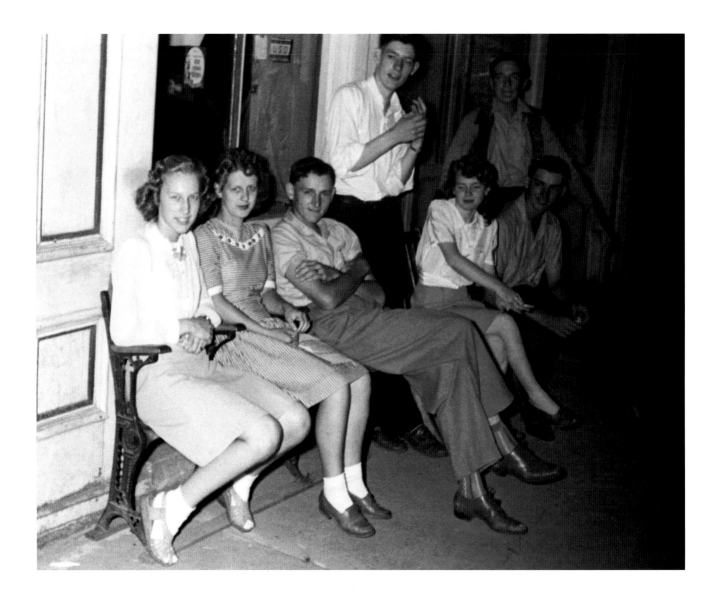

Saturday Night

Q (referring to pictures that must have been taken in the dark): *How did you take these pictures? You didn't take that with a flash, did you?*
Everett: *No, I think the one that was called "Saturday Night" is the only one taken with a flash. First of all, cameras didn't have any sync. We had to figure out how in the world you were going to get a picture taken with sync.*
Q: *You must have had pretty fast film.*
Everett: *This film was all Super X, Super Double X. I don't remember what speed it was. It was the fastest available at the time, I think. Many of the series that I got, many of them were time shots.*
Q: *You used a tripod?*
Everett: *No, I didn't use a tripod so much . . . But I'd lean on the corner, and some of them didn't work. They'd have to be by guess because 1/25 was the slowest speed I had on the camera.*

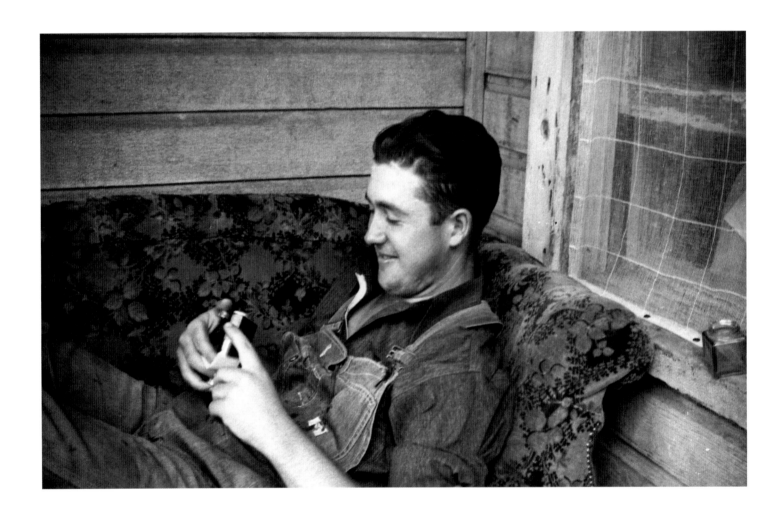

Roy Rolling His Own

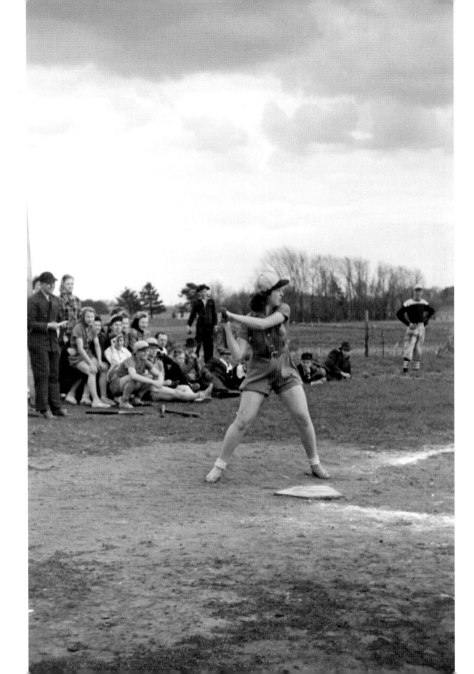

Baseball Fans

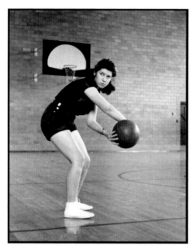

Basketball Ruth

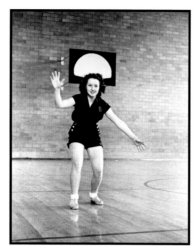

Basketball Alice

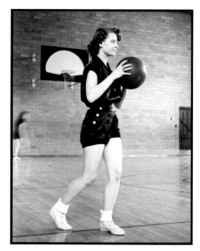

Basketball Junice

SIX-GIRL BASKETBALL PLAYERS

This was the era of the six-player girls' basketball team, a tradition that went back to the 1890s and didn't end in Iowa until the 1990s.

In the six-player team, three guards stayed on one side of the mid-court line as defenders, and three forwards stayed on the other side as the offense.

It's no coincidence that only three of the six are holding a basketball in these photos. The forwards did all the scoring.

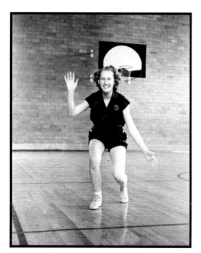
Basketball Norma

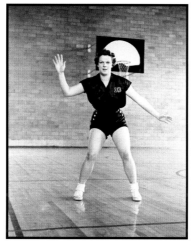
Basketball Dorothy

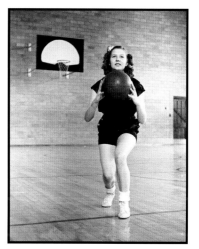
Basketball Betty

The rules were tough and included such basics as

a. bounce the ball no more than twice before passing

b. do not cross half-court

c. don't swat at the ball when the person with the ball is outside of the lane.

Did switching to men's rules speed up the game? Some remember the six-player games as very scrappy with crisp passing and a frenetic pace. Are those calluses on some of these young women's knees?

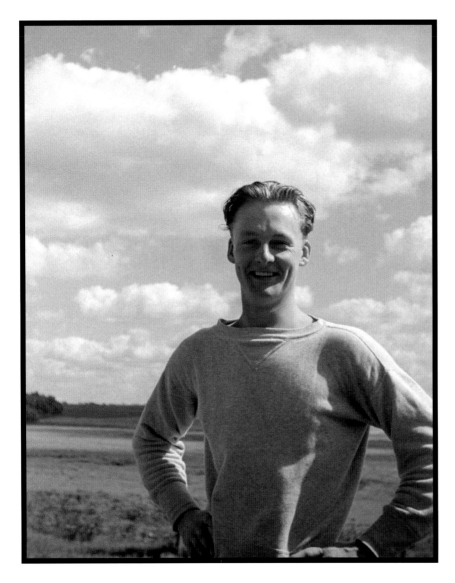

Confident Young Man

Though the war goes on, the U.S. tries to remain neutral, even as Hitler's armies invade the U.S.S.R.

In April, the U.S. Department of Agriculture under Claude Wickard states, "Food will win the war and write the peace."

In June, all Japanese assets in the U.S. are frozen.

Mary O'Hara's *My Friend Flicka* is published and author Sherwood Anderson dies.

Well before Pearl Harbor, Joseph Clark, the U.S. ambassador to Japan, sends a warning to U.S. Secretary of State Cordell Hull: "The Japanese are planning . . . a surprise mass attack."

While Pearl Harbor is being attacked, Chaplain Howell M. Forgy, who was on board one of the ships, coins the phrase, "Praise the Lord and pass the ammunition."

Meanwhile, back in Iowa on the day of the attack, Bob Hope's comedy *Nothing but the Truth* is playing at the Decorah theater a few miles from Ridgeway.

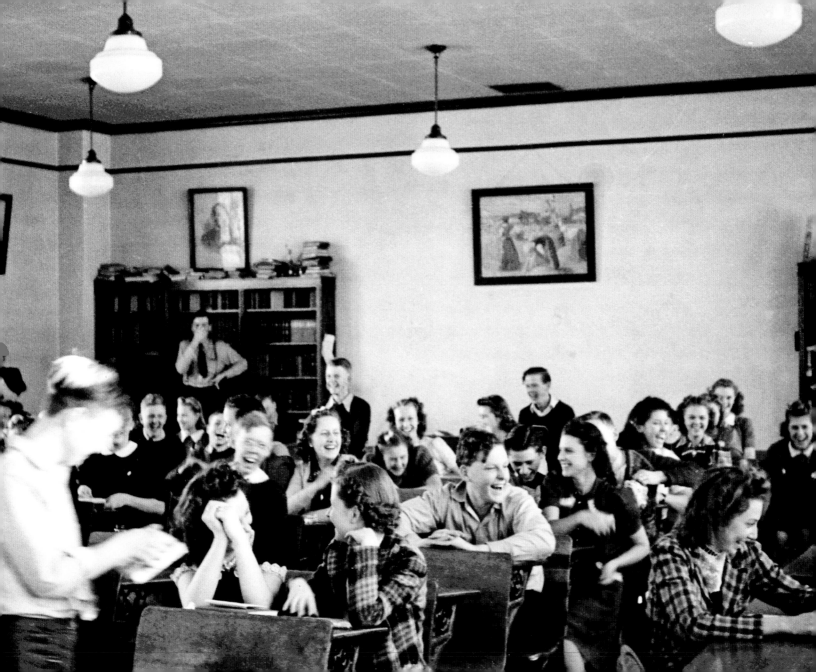

These were not the years of great improprieties, but the class clown knows that if he is reading from something that is in print, he is probably free from condemnation. Whatever he is reading is embarrassing everyone. They are looking around for support.

Is whatever he is reading to the class just short of PG-13? Is the teacher in the background covering his mouth so others will not see that he is laughing too?

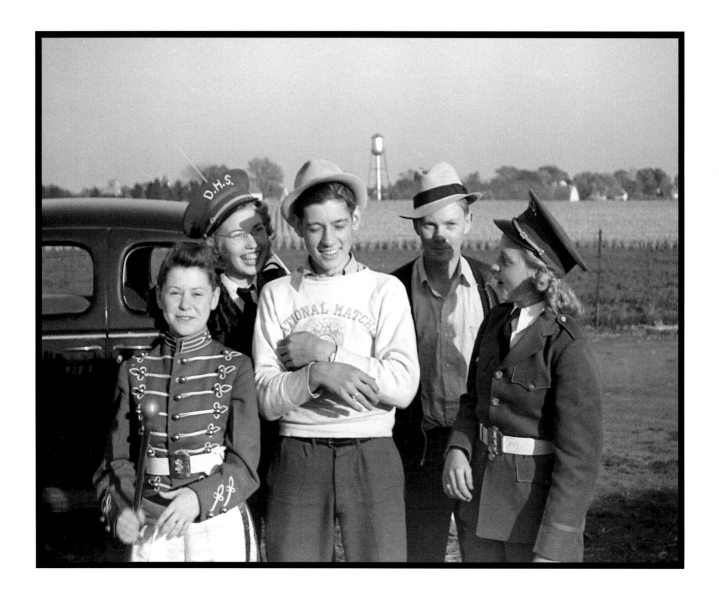

Decorah High School Band

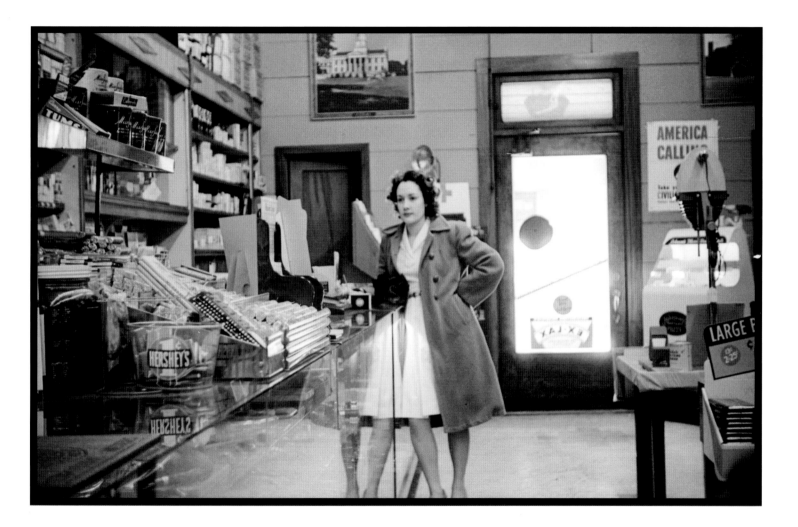

Henry Louis's Drugstore, Iowa City

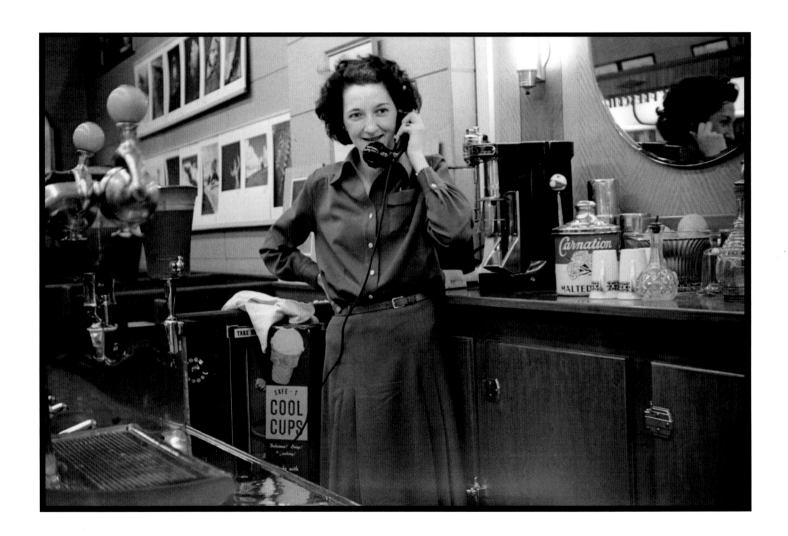

Henry Louis's Drugstore, Iowa City

A modest waitress dress invites modest expectations from the customers. The belt buckle does not have to be centered, and the bar rag does not need to be neatly folded.

How much is she making for this work? Probably 1941's minimum wage of thirty cents an hour.

But the telephone conversation: look out, what is being said and heard there may be anything but modest. In Ridgeway, for example, if enough people are listening in at the barbershop switchboard, customers may soon come streaming in to hear more.

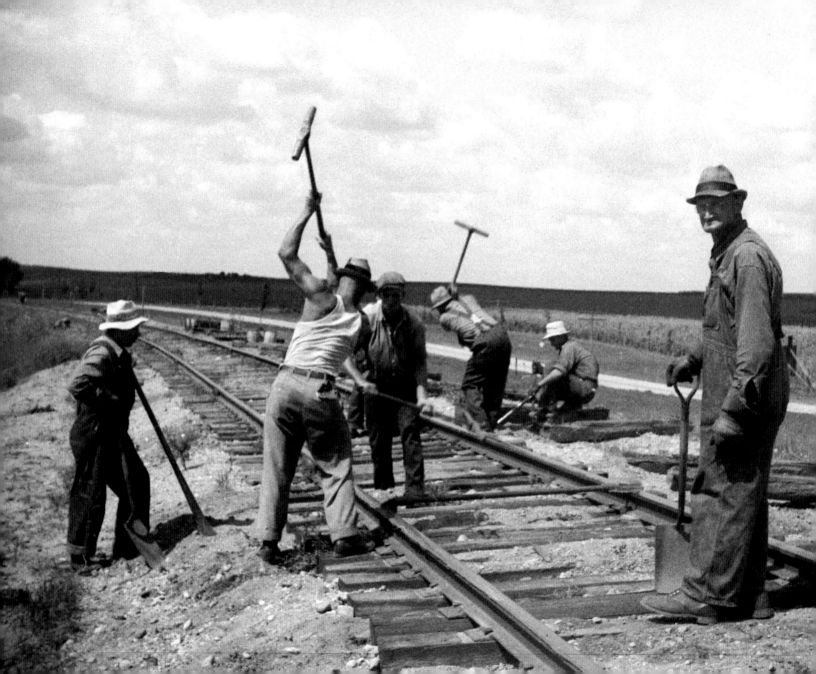

Synchronized hard work. Call the tool a gandy. Call the work a dance.
No wonder the workers sang:

Pick and shovel—HUH!
Am so heavy—HUH!
Heavy as lead—HUH!
Pickin', shov'lin'—HUH!
Pickin', shov'lin'—HUH!
Till I'm dead—HUH!
Till I'm dead—HUH!

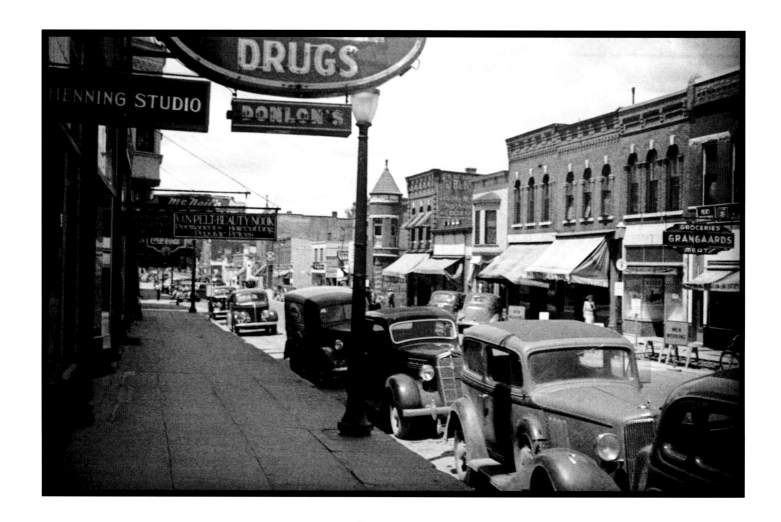

Donlon's Drug Store, Decorah

Work Train, Ridgeway

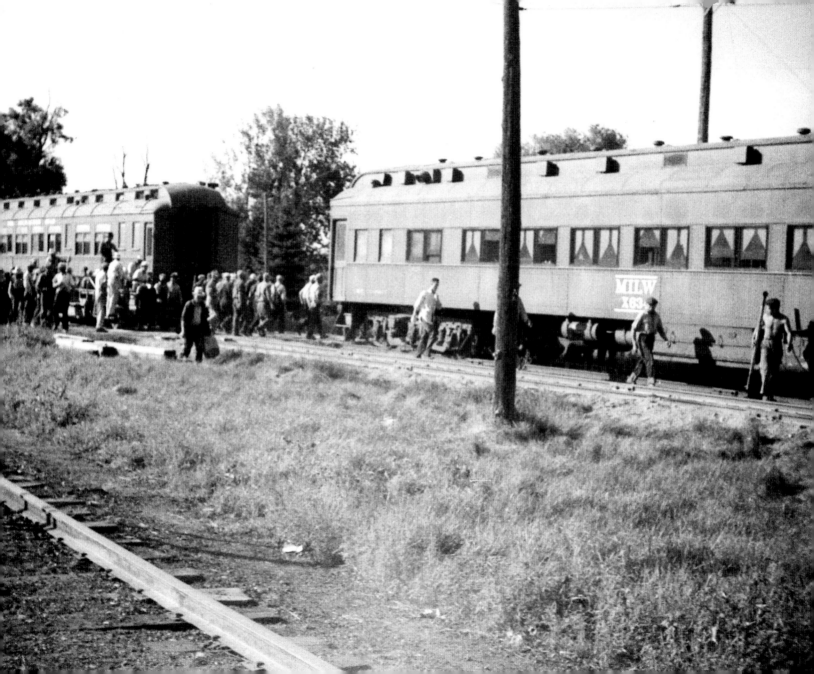

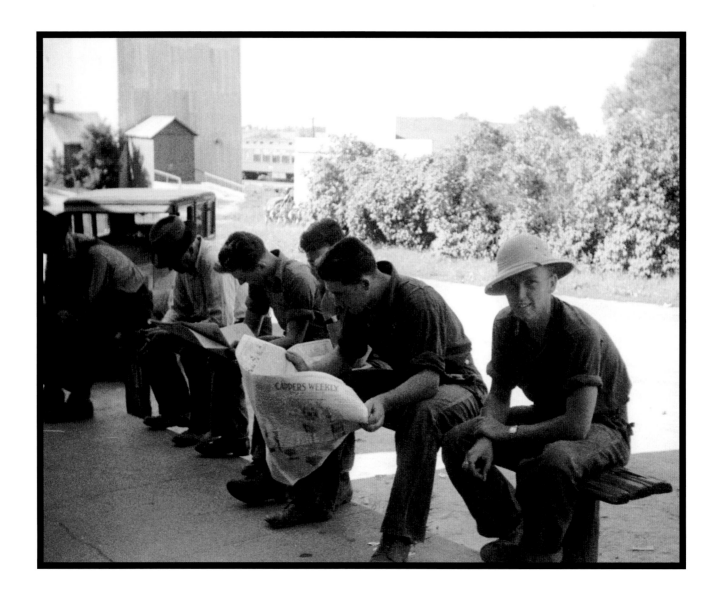

Capper's Weekly

This little newspaper started in Kansas and spread across the rural Midwest like sparkling sunflower faces. It was an upbeat publication with poetry, cooking, sewing, and gardening tips—and mostly news that people would want to read, especially people whose lives were not as rosy as the positive outlook in dear little *Capper's Weekly*. It was anything but work and probably more relaxing and less expensive than a beer at a local bar.

Everett: *This picture is I think in front of the Soda Grill. There was a bench there. . . . Maybe some of these guys are railroad workers. . . . They do look like a group of guys who have just finished work and are taking it a little easy. Possibly the work train has moved away.*

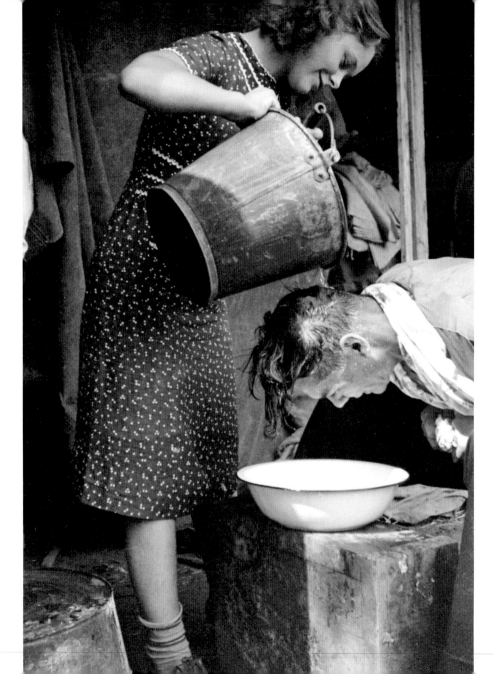

Migrant's Salon

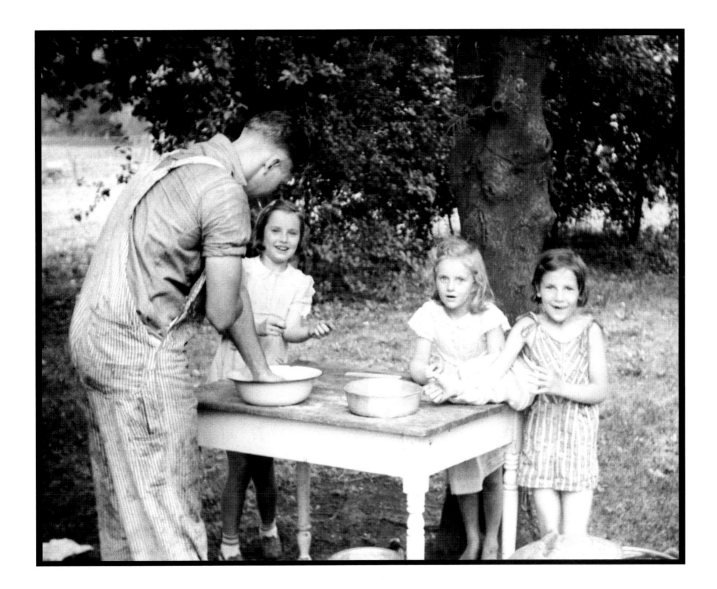

Thresher's Washroom

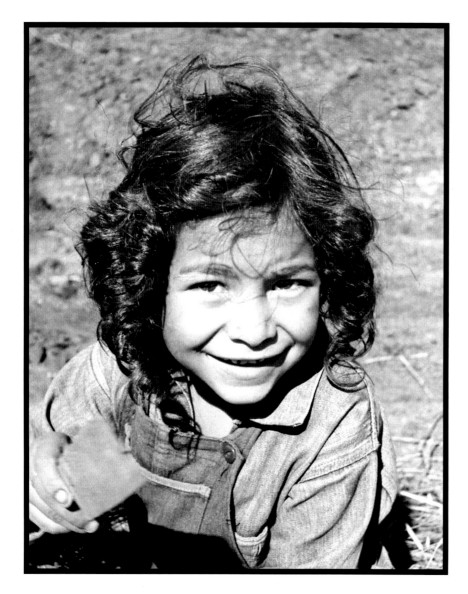

Migrant Child

In response to the labor shortage, Mexicans started arriving in Iowa to work on farms in the early 1940s.

Everett: *This is a little Mexican child. I don't know who she was, but she had a nice smile.*

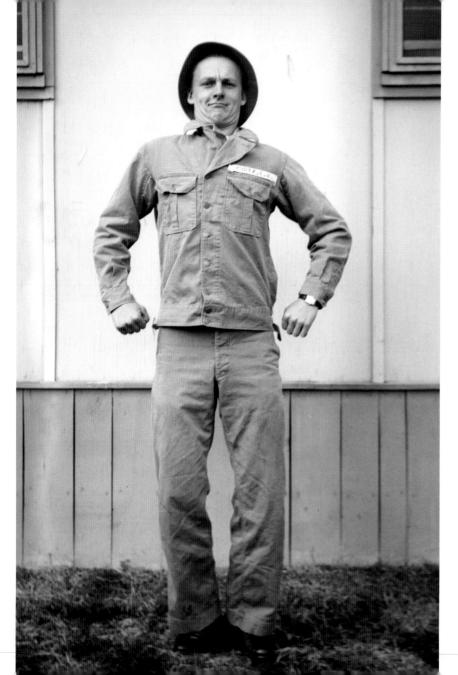

Everett at Attention. Chanute Field.

In Washington, D.C., the president orders all aliens to register, a move that will lead to Japanese American internment camps, and by April coastal blackouts go into effect along the eastern seaboard. These facts probably did not affect the small Ridgeway community, but the sugar and gasoline rationing that started in May would have.

In October, the first jet airplane, the XP-59, is tested in California.

By November, the draft age has been lowered to eighteen.

By December, coffee has joined the list of rationed items.

And the World Series is won by the St. Louis Cardinals.

Joe Louis defends his title for the twentieth time.

Iowa painter Grant Wood dies, and in the fashion world, simplicity and economy become the guidelines as part of the war effort.

In the fall, Everett enlists in the air force—and takes his camera with him.

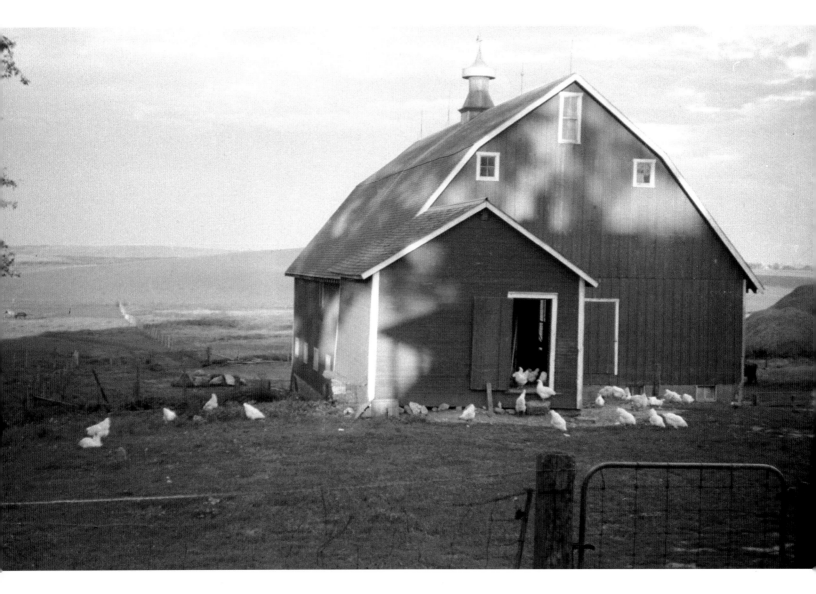

Barn with Chickens

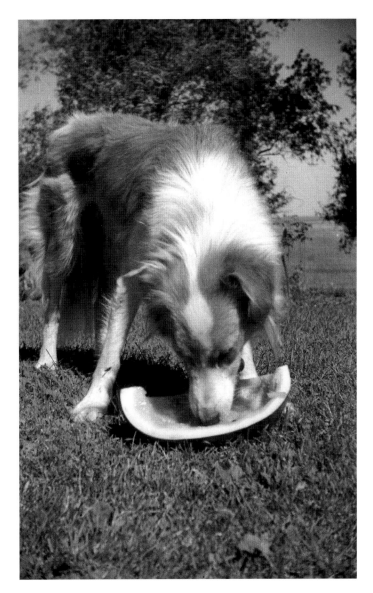

Dog Eating Melon

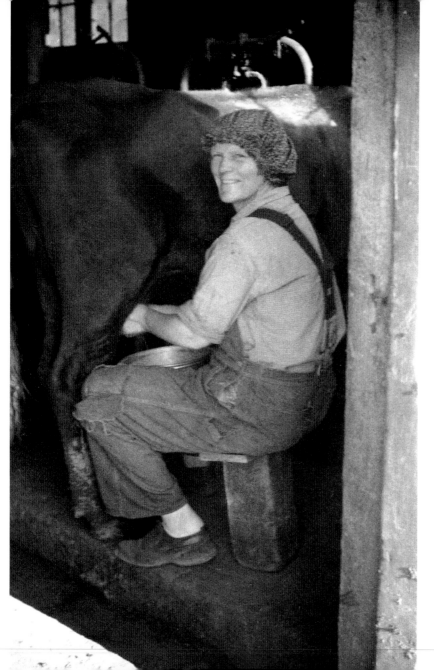

Mom Milking

"An extra squirt from every cow."—U.S. government slogan to encourage farmers to
increase farm productivity during the war

"I realized that all the really good ideas I'd ever had came to me while I was milking a cow.
So I went back to Iowa."—Grant Wood, the Regionalist painter born in Anamosa, Iowa,
most famous for his painting *American Gothic*

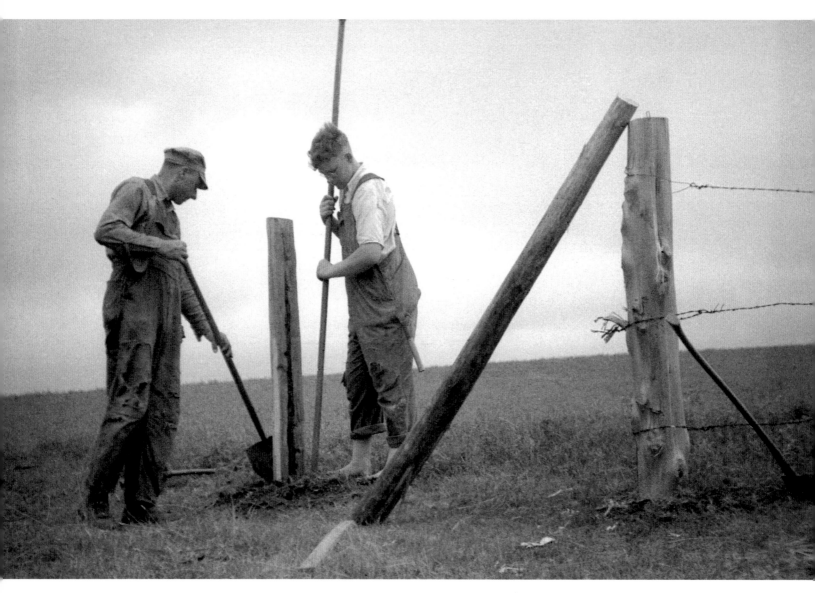

Setting an End Post—Dad and Harold.

It's hard to imagine from this photograph that cash from Iowa farms increased by 60 million dollars between 1938 and 1939.

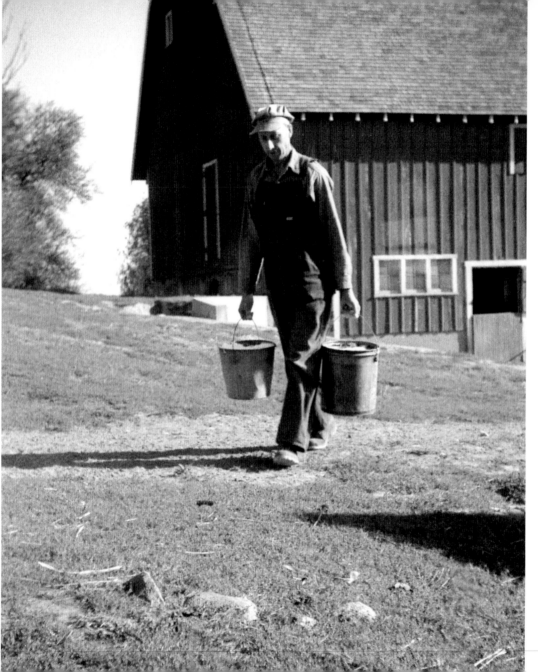

Milk Buckets

Why would he carry fresh milk in such old buckets that allow the milk to slosh onto the ground? And where is he carrying the milk? There's more milk here than anyone could put on their cereal.

All this milk is not heading toward the house or toward any respectable human being. This is skim milk, not worthy of human consumption. Drink skim milk? That would be about as low as eating carp. He's carrying this useless milk to the pigs, who will at least be able to transform it into something fit for human consumption: good fatty pork chops and ham.

This is not the only trip he'll be making from the barn to the hog troughs. Other old buckets of skim milk are waiting in the barn, while the precious cream waits in separate, shiny clean cans. Much of that good rich cream will be sold to the creamery. The rest? It will go onto his cereal in the morning and help build the strong muscles he needs to carry this useless skim milk to the pigs.

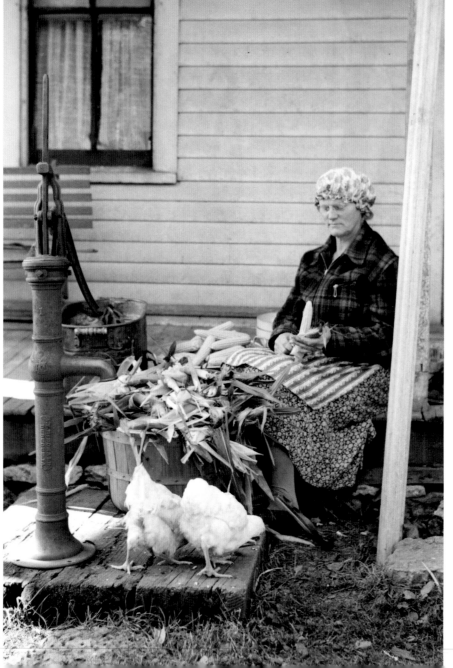

Mom Husking Corn

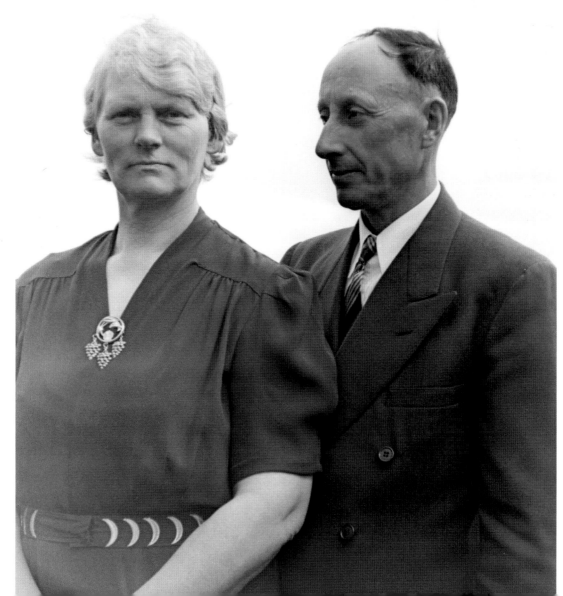

Mom and Dad. Augusta
and Walter Kuntz.

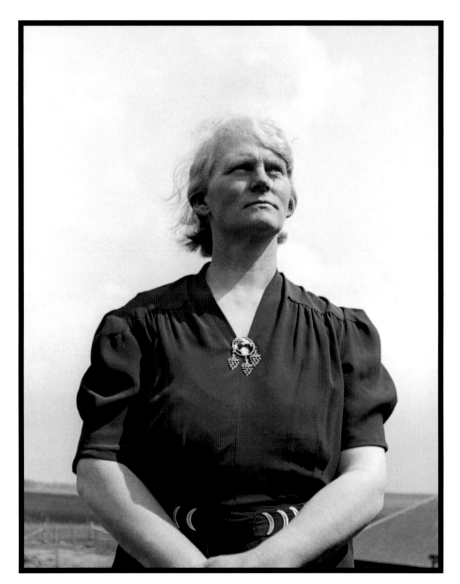

Mom

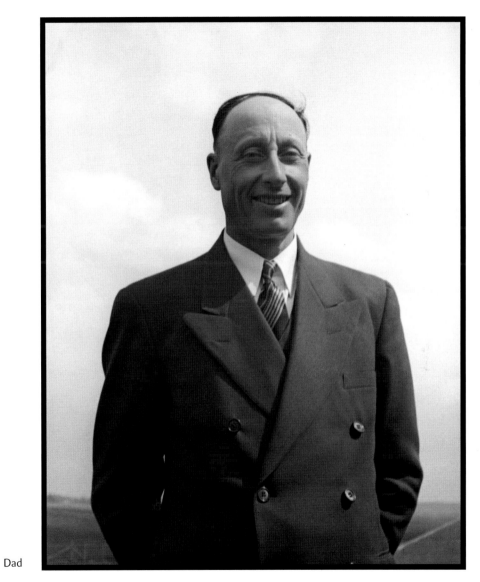

Dad

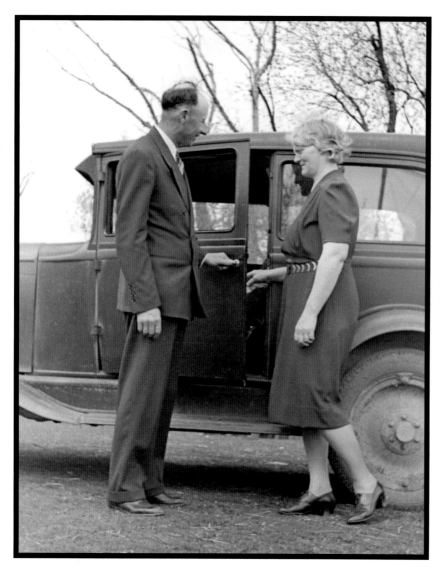

Mom and Dad—1939 Chevrolet

Mom's Sunday Dinner

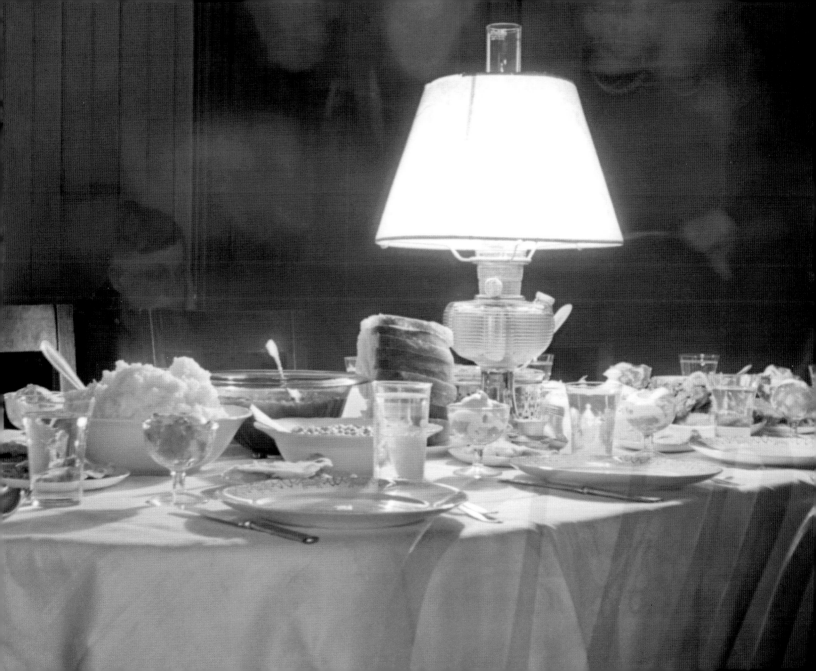

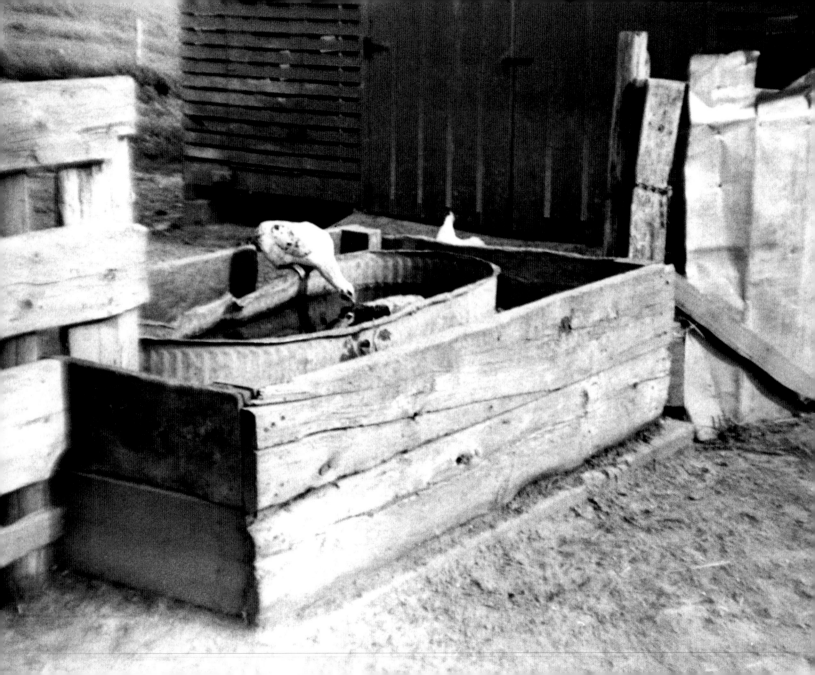

All Four of Us

Thirsty Chicken

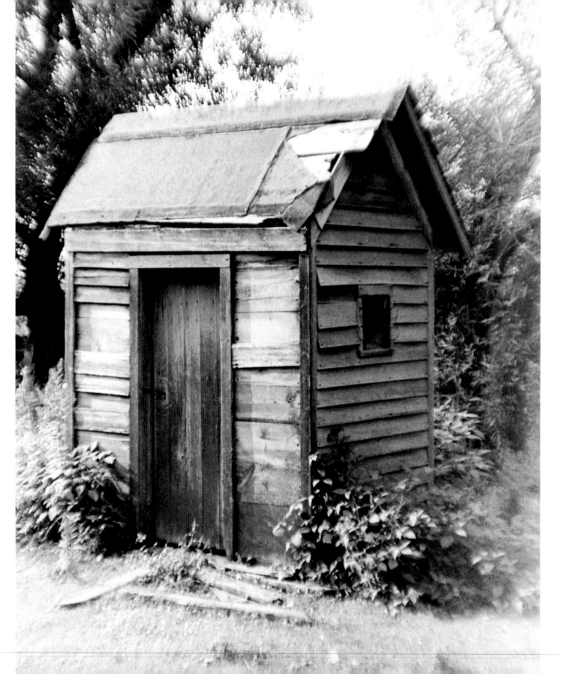

Outhouse

Is this thing like an heirloom on the shelf, slightly bent out of shape but reminding everybody of somebody or something from the past? No one has worn a fresh path to the front door, so we know that an indoor toilet has made this decrepit creature irrelevant.

There must be some good reasons why no one has torn it down. It's even equipped with a few loose boards out front to keep shoes from getting dirty after a rainstorm. It's more than an emergency facility. It can also serve as a meditation center for anybody who needs to get away from everything without somebody knocking on the door. But it has an even greater purpose: it sits there like a great-great-grandfather in his old overalls, as one who has graduated from the small world of *function* into the grander world of *symbol*.

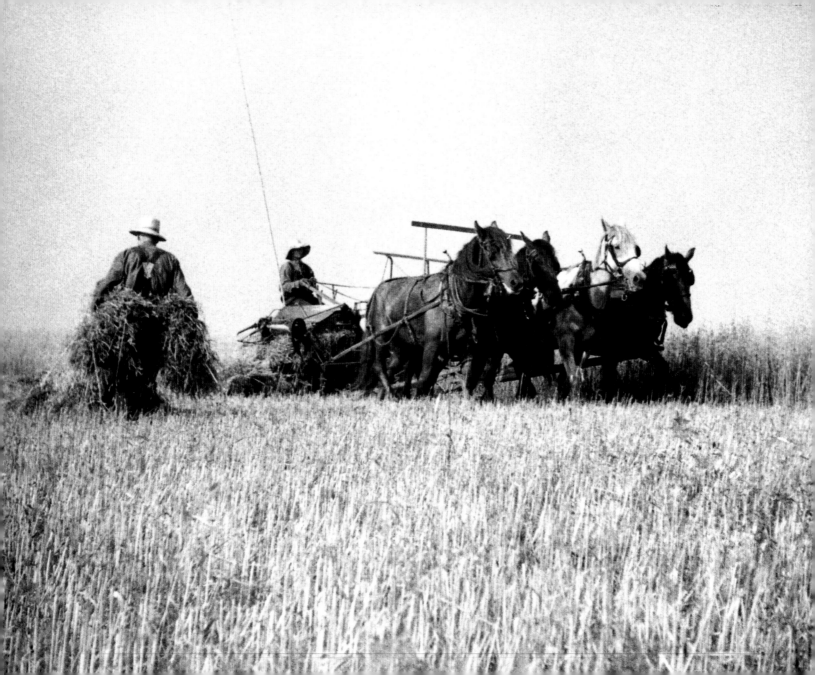

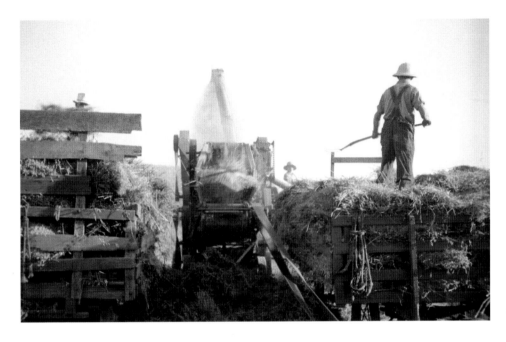

Threshing

"You think knee-high by the Fourth of July?"
"I think knee-high to a grasshopper."

"So windy at my place, the wind blew the post holes right out of the ground."
"Should have seen my place. So windy this one chicken laid the same egg three times."

"Yep. Good years it's so good you don't want to leave."
"Yep. And bad years it's so bad you can't."

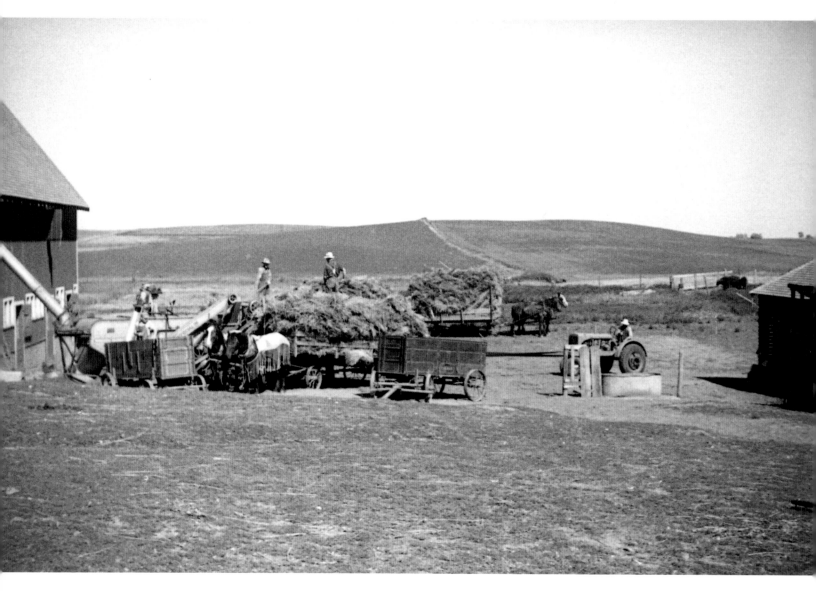

Threshing

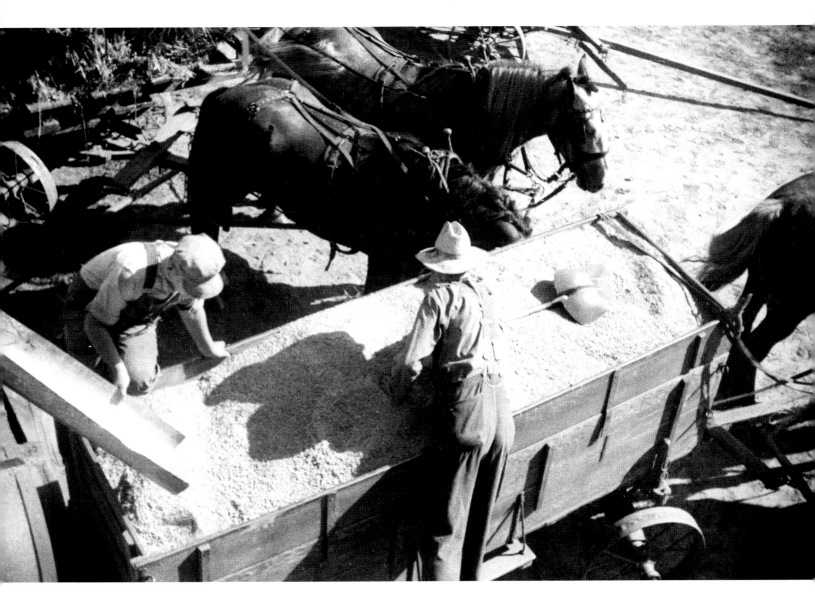

Oats Harvest

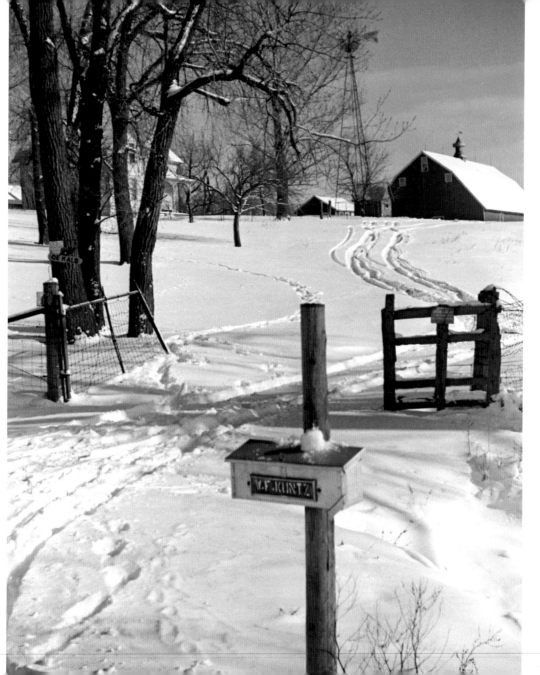

Winter Home

Family Perspectives

EVERETT HAD A CONSTANT INTEREST in photography from the day we met until his death. Throughout our marriage he took movies, hundreds of slides, and black-and-white and color prints. He covered a few weddings and countless school, church, and family events. We developed our own Christmas cards while most people took them in to be finished or had them taken by a professional. He was a true photographer even though engineering was his profession.

HELEN M. KUNTZ

A CURIOUS MAN, my dad. Intensely interested in every single subject that ever came along, he could never understand how someone could possibly be bored. All around were wonderful, mundane, strange, or even fantastic people, places, or things that simply had to be investigated. This eager desire transformed Dad's life into a journey to learn more.

Who were these people around him, and what were they doing? It was this insatiable curiosity that took him in the spring of 1939 into Henry Louis's drugstore in Iowa City, where he felt compelled to spend his entire savings of $12.50 on a 35mm Argus AF camera. The images he would capture in the four years that followed no doubt provided answers to some of his questions.

"Do with your life something that you really want to do," Dad always told us. Fulfilling this endless curiosity through photography was one of his favorite things. The incredible photographic images that he captured from 1939 to 1942—of town life, the farm, or church picnics—tell the story of a bygone era, an old-fashioned time of family, God, and country. My dad's time.

DAVID E. KUNTZ

MY FATHER INSTILLED IN ME his love of learning, of nature, and of photography. As a kid, I remember helping him develop film, and I remember the first Brownie camera he bought me. He would talk to me about lighting, picture content, and composition. He always said that most anything could make a picture interesting if you just looked at it from the right perspective.

When I took photography classes in college and worked in the darkroom, I would smile to myself and think of Dad. Now, as I see my daughter's interest in photography and her interest in her grandpa's old photo equipment, I realize he has left a wonderful legacy. His love and interest in the things around him will continue in the generations to come.

CAROL KUNTZ SWENSON

DAD, A BRILLIANT MAN, a master at engaging in meaningful activities.

A keen observer, constantly attending to detail, be it simple or complex.

A man of few words whose pictures are worth thousands of words.

A patient and thoughtful man when making decisions about life as well as about the subject and composition of a photograph.

A man who seemed most content when taking it all in behind the eye of a camera.

Family and friends grew to anticipate Dad with his camera in hand. "Where is Everett? We need a picture," they'd say. You could see a slight level of distress on their faces because this was serious business. Everyone knew Dad took great pictures. I've been asked many times, "Is your dad a professional photographer?" A tough question to answer. In my mind, he was.

NANCY KUNTZ HILDRETH

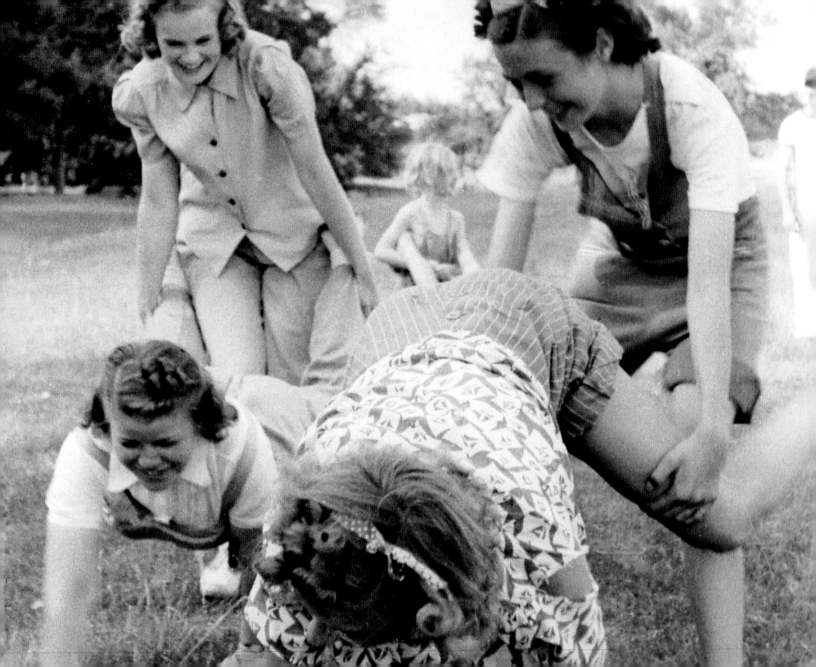

ACKNOWLEDGMENTS

THANKS TO THE PEOPLE who helped make this book possible, some by bringing Everett's photographs to the attention of the world and others for lending behind-the-scenes support:

Lynn Barton, owner of the Bru House in New Brighton; Sue Kosmalski, art instructor at the University of Minnesota and at the College of Visual Arts in St. Paul; Craig Norkus of KARE-11 News in Minneapolis; Ed Day of the *New Brighton Bulletin*; the *Decorah Public Opinion*; Peg Meier of the *Minneapolis Star Tribune;* Joe Soucherey of KSTP AM 1500; David Knight for his technical support; Rex Wood for his insightful interview on April 20, 2003, with Everett shortly before his death—an interview from which Jim Heynen quotes in his lyrical passages among the photographs; Holly Carver, director of the University of

Iowa Press; the Chatter-Box Cafe in Ridgeway; the Nob Hill Supper Club in neighboring Decorah; and the Old World Inn in nearby Spillville. And finally to the town of Ridgeway, where the townspeople, the Community Center, and Ridgeway High School and its reunion committee did so much to bring Everett's images back home.

Special thanks to the people at the Decorah, Iowa, Public Library, where Jim Heynen gathered information from newspaper clippings, especially from the *Decorah Journal*, 1939–1942.

HELEN M. KUNTZ

SUNDAY AFTERNOON ON THE PORCH

Design and composition by Kristina Kachele Design, llc

Set in Miller Text with Eva Pro Normal and LTC Swing bold display

Printed in China on Gold East Matte paper by Everbest Printing Company
through Four Colour Imports, Louisville, Kentucky